DON MCLAUGHLIN

BOLIVIA

Looking Beyond Its Rocks

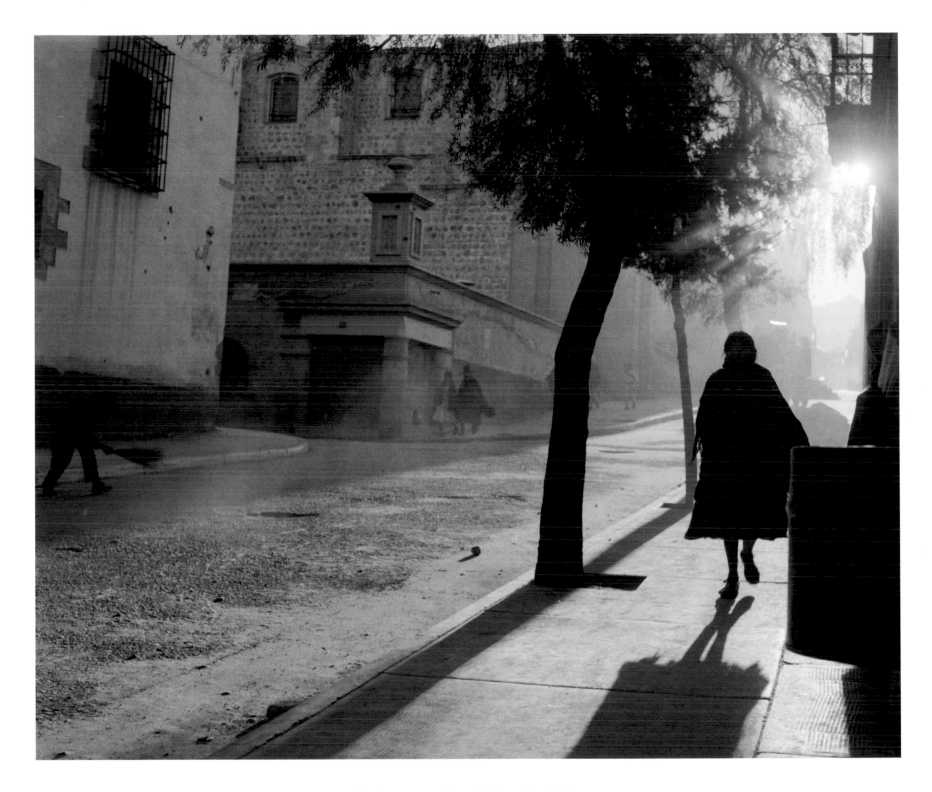

Early morning. Potosí. December 1960

FIELDS
PUBLISHING

First Edition

McLaughlin, Don.
McLaughlin, Bolivia, photography and commentary by Don McLaughlin.
132 pages, 27.94 x 30.48 cm.
ISBN 978-0-9759060-1-1
Library of Congress Control number 2007932642
1. Bolivia, South America, 1959-1962—Black and White Photography—World Travel—Geology—Oil Exploration.

Cover photo: Early morning, Potosí. December 1960
Photo Editor Charles Fields
Edited by Martine Jore and Holly McLaughlin
Book Design by Gail Fields and Charles Fields
Prepress Consultant Glen Bassett
Production Assistant Zheni Valcheva

∞ This book is printed on acid-free paper meeting the requirements of the American National Standard for Permanence of Paper for Printed Library Materials

Printed in Korea.

Fields Publishing, publishers of Fine Art and Photography books and winner of the 2007 Benjamin Franklin Award - Best Art Book "Anne Packard", offers quantity discounts for corporate and group sales, educational, business and sales promotions.

DEDICATION

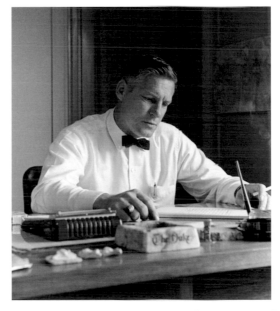

I'm dedicating this book to the memory of Jim Carney, an enriching friend and a superb boss. In 1958 we met, as young geologists, in San Francisco. I was delighted when he asked me to join the Chevron exploration group in Bolivia. He trusted me to explore the vast area east of the Andes, where we had one of our two concessions, and put together the geological picture.

He was also interested in my photography and once even lent me the company plane for that purpose.

The photographs in this book would not have happened without him.

—Don McLaughlin

FOREWORD

On a warm, sunny day in 1954, after two degrees in geology at Berkeley and hard at work on the third, I pulled my head back from my microscope and said "to hell with it". My training had been in oil geology and I didn't need any more degrees to do that. I needed an employer. So I went to San Francisco, saw Ken Crandall, Standard of California's top geologist and wound up in Ecuador via Argentina.

In 1959 I was transferred to Cochabamba, Bolivia, and told to sort out the geology of the Bolivian Chaco, that vast, largely trackless plain, mainly covered with spiny scrub forest, that lay east of the Andes.

Field geology, especially in a place like the Chaco, is hardly a solitary enterprise. To aid me I had a three-man field crew composed of a surveyor, driver-mechanic, and cook. Without these fellows nothing would have happened. We did our jobs and had fun doing them. We eventually covered some 60,000 square kilometers, roughly the same size as West Virginia, and I would have liked to have covered more as the more problems we thought we'd solved the more we found. In addition to the Chaco, we made numerous trips studying the Eastern Andes where some of the Chaco rocks that were deeply buried in the Chaco were uplifted and exposed in the mountains. It was relief to get into the cooler high country where we didn't fight for every outcrop. And there were no bugs.

As working in the Chaco often kept us in isolated places for up to a month, we became known to the local population, what there was of it, occasionally hired some of them, mainly as guides, trail choppers, and mule skinners. I photographed many of them and would make every effort to get the prints out to them.

Life out there in the back of beyond is what you want to make it. The job was tough in many ways, especially in the Chaco where we did most of our work. Every bush seemed to be spiny and bugs abounded, especially in the rainy season. In the early evenings the no see'ums would come at us in clouds. The most dangerous there were the anopheles mosquitos with their malaria virus which shut me down for a month or so. Sometimes the job became risky in the areas where the Ayoreos, the aboriginals, lived. In the Bolivian Chaco they had been pushed to the south where they congregated around the Paraguayan border and, understandably, they resented our intrusions. But just working in the Chaco was always exciting. Sometimes we'd get lucky and find a new bit of geology, maybe just an outcrop or a fossil, that can have regional significance and change basic ideas. That was really exciting.

In sum, I was sent to Bolivia to help find oil. After two dry holes and some sixteen million dollars of expenses, we found none. However, I did find a fascinating country and had a wonderful time probing it with my lens, the results of which I wish to share with whomever might be interested. Hence, this book.

—Don McLaughlin

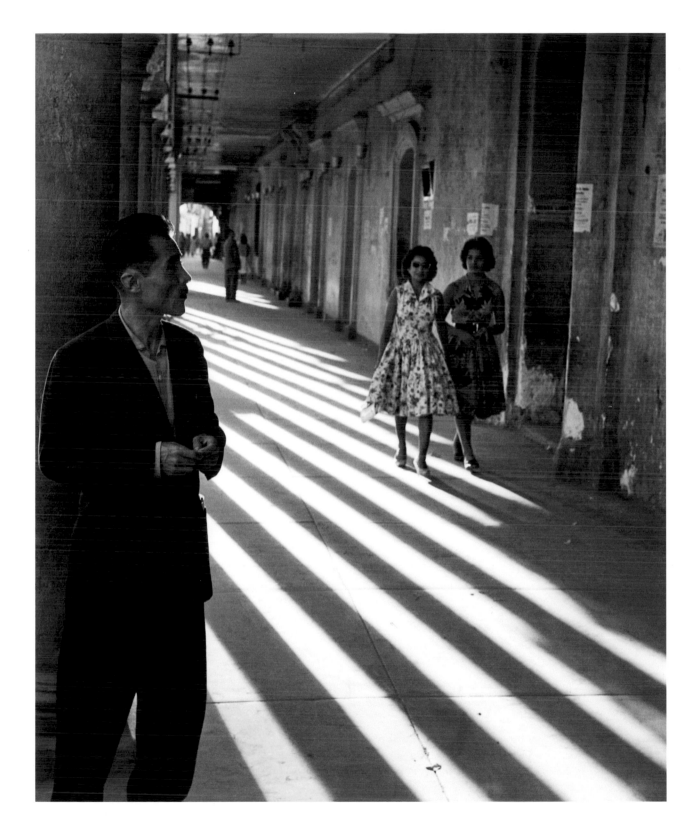

On the north side of Avenida Libertador next to the Plaza 14th de Septiembre.
Cochabamba. January 1961

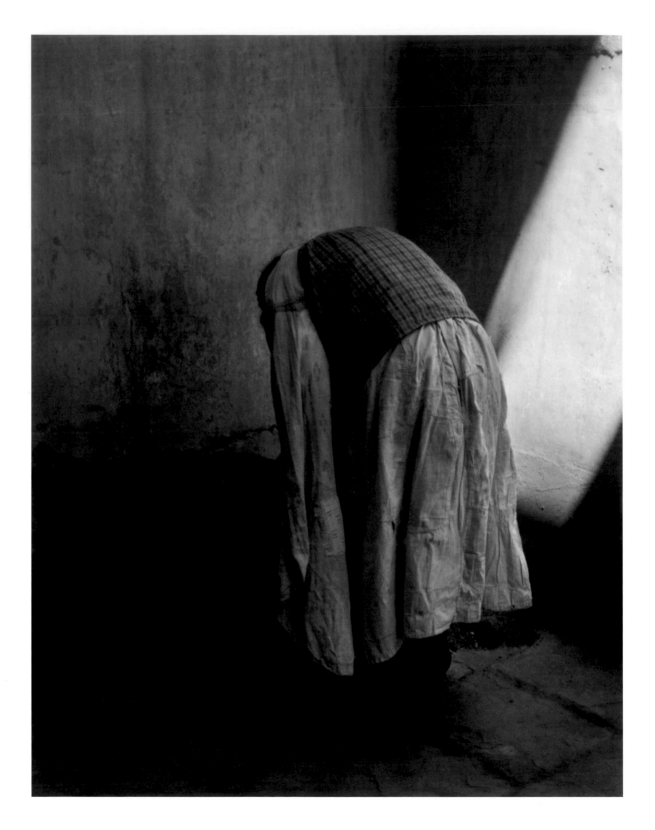

A bent little old lady in a patio of a house near Plaza 14th de Septiembre.
Cochabamba. January 1961

BIOGRAPHY

15 July 1926 Born in Evanston, Illinois and moved to Cambridge, Massachusetts in the fall of that year.

1931-1939 Attended various schools in the Cambridge area.

1940-1943 Attended Phillips Exeter Academy but without significant success.

1943-1946 Joined the US Navy. Served in the US and the Philippines.

1946-1954 Settled in Berkeley California, finished high school, attended the University of California at Berkeley and, this time, with significant success in the form of two degrees in geology.

1954-1958 Worked as field geologist for the Standard Oil of California in Ecuador.

1959-1962 Transferred to Bolivia as a field geologist.

1962-1964 Transferred to Roswell, New Mexico as an office geologist.

1964-1971 Left SOCal and worked for the foreign branch of the US Geological Survey in Colombia doing field work in the Eastern Andes and training Colombian geology graduates in the techniques of field geology.

1971-1972 Joined the Hanna Mining Company as field geologist.

1972-present Left Hanna and moved to Cape Cod, Massachusetts where my family was currently living, wrote geological papers, writing and speaking on energy matters, played clarinet in several Cape Cod bands and sailed on Nantucket Sound. Also returned to photography, printing then showing the Bolivian work, doing portraiture and black-and-white work on Cape Cod.

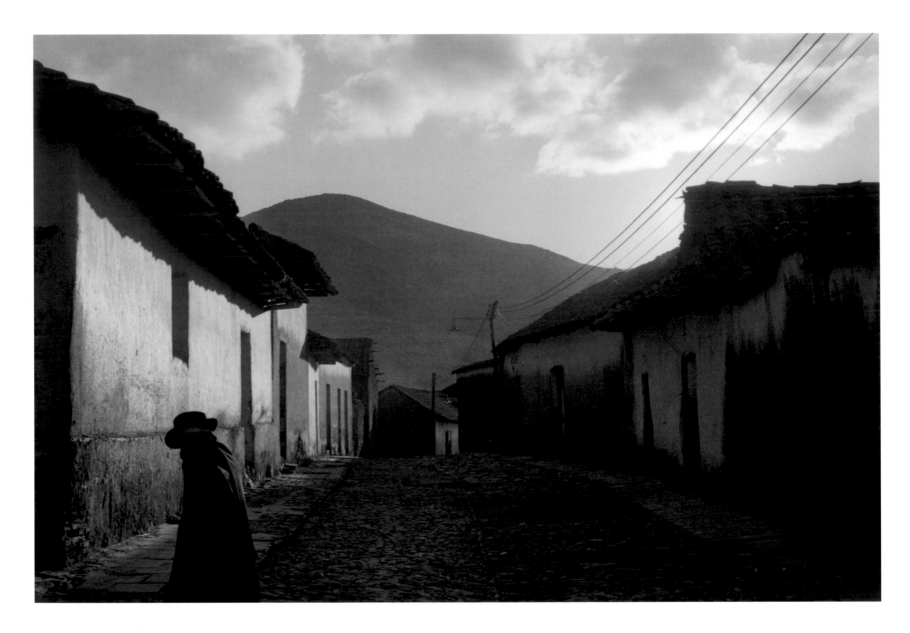

In 1959 we camped at the north end of the airstrip here. In 1967 Che Guevara put the place on the map when he was buried
very close to the place where we pitched our tents.
Vallegrande. June 1959

PHOTOGRAPHER'S STATEMENT

Photography and I came together around 1936 when someone gave me a Kodak box brownie and a few rolls of film. Several years later I got a Kodak 620 folding camera with f-stops and shutter speeds. After running a roll or two of Verichrome through it with paltry success, I bought an Expophot exposure meter which gave me a feel for light and its tricks. Along with the meter I also got a copy of Eastman Kodak's *How To Make Good Pictures*. And I was off and shooting—until 1943 when I joined the navy.

After the war I resumed taking pictures with my Kodak 620 but, I was intrigued by 35 millimeter cameras and bought a pre-war Contax II and a Weston meter. In addition, I began to pay attention to the likes of Cartier-Bresson, Strand, Walker Evans, Weston and the rest of the heroes of that time. In 1954 I moved to Ecuador and found a photographic feast. With the Contax II, I began shooting Kodachrome, a great film, and most of my slides from that time are still in good condition. Back in those days, Kodachrome shot in South America had to be mailed to Europe for processing which often meant a delay of up to six weeks before the slides were returned and you saw what you had taken. Sometimes I never did see them, transatlantic mail being what it was then. So when I went to Bolivia my emphasis was on black-and-white and my own darkroom so I could see what I was doing. I still continued taking slides, however.

As reliable photographic supplies were not available in Bolivia, I had to buy mine in the States when we were on vacation. There was no popping down to the local photo store if you turned on the darkroom lights inadvertently. Bolivia made one careful.

In my wanderings around the country I shot Kodachrome with my old Contax II, Plus X-Pan with a new Contax IIA and a new Nikon F. To photograph all those Bolivian "geoscapes," I bought a medium format Rittreck SLR and used Verichrome 120 film. Most of my Bolivian pictures, however, were made with the new Contax IIA and those gorgeous Zeiss lenses.

Finally, I've always thought of myself as a field geologist who loves taking pictures. It was great fun. The hobby fits in perfectly with our work. We travel; we see; we photograph. In the last few years, people who had seen my photographs began suggesting that I show them in public and I started taking this hobby of mine more seriously. Out of these shows came the idea of this book. All this comes late in life as the consecration of parallel careers of which I was largely unaware, that of being both a field geologist and a photographer, not only a geologist.

Don McLaughlin

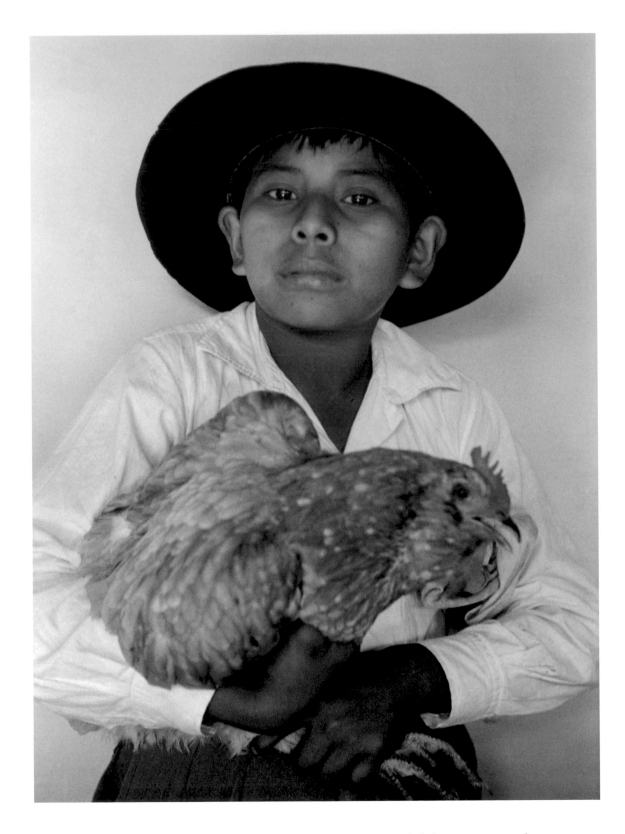

Boy with chicken at the Alojamiento Pacheco. As there was a cock fight in progress at the time,
whether the bird wound up on our plates or in the arena was never determined.
Roboré. May 1961

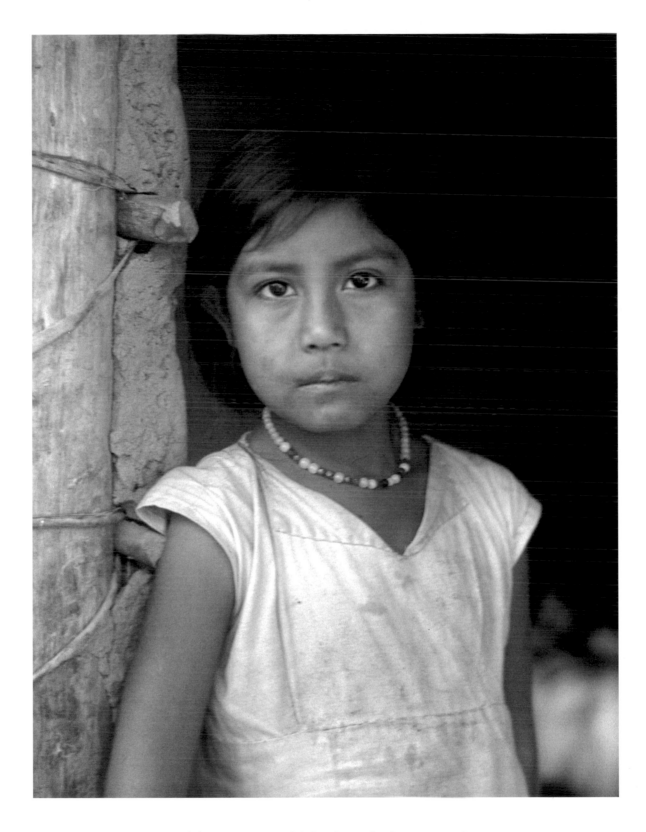

Elida López, our guide's daughter. Chochis. June 1961

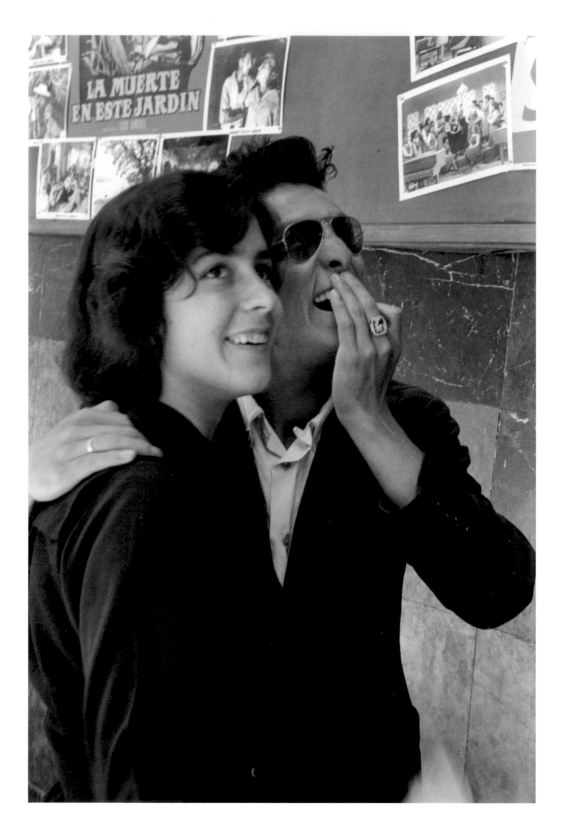

Young couple reading a movie poster at the entrance to Teatro Astor.
Cochabamba. October 1961

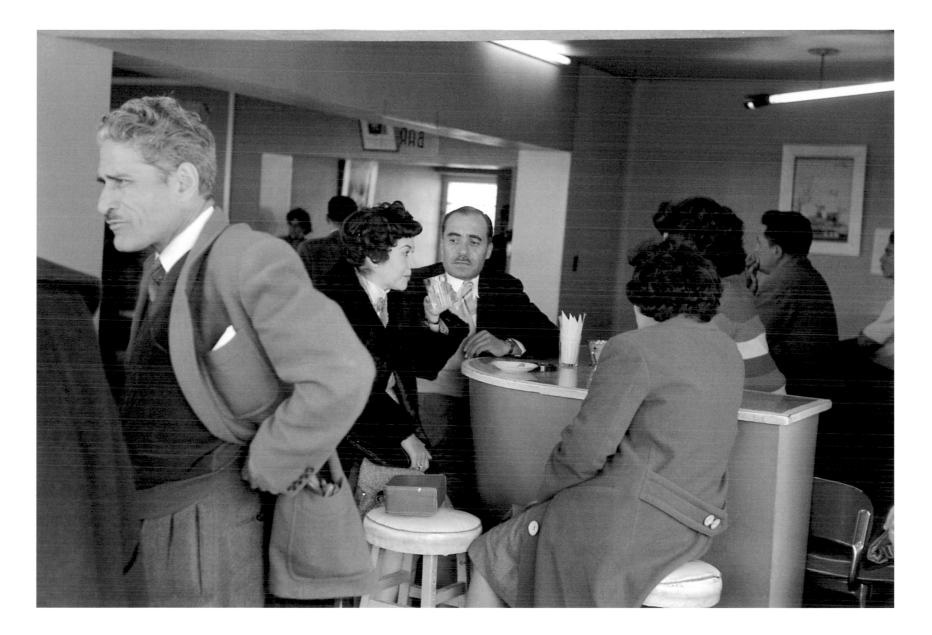

Waiting room at La Paz airport. The gentleman on the left seems to had heard all he wanted to hear. El Alto. July 1960

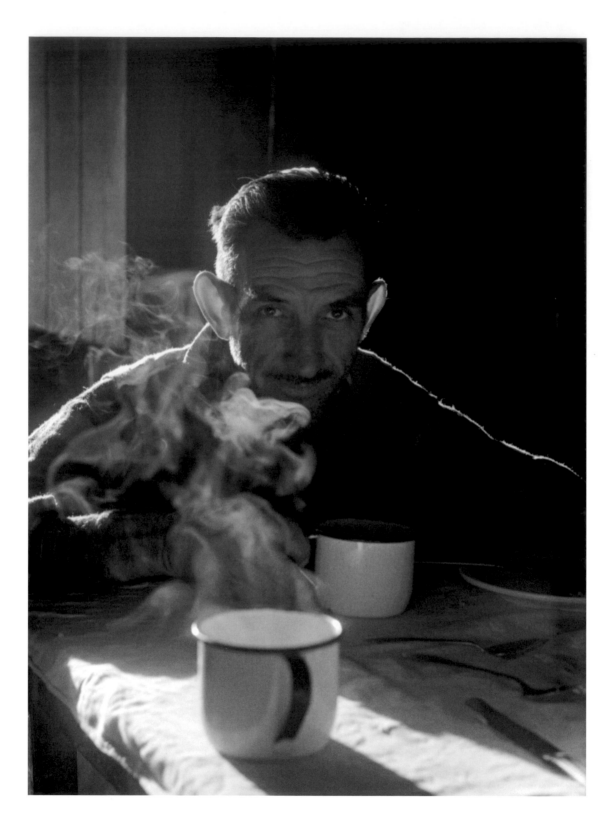

Lupo Giorgetti. Morning coffee at the school house where we stayed at Taperas, eastern Bolivia.
Lupo was the motorista for our Fairbanks rail speeder and also a gifted ventriloquist,
a talent he relished in displaying as the trip progressed. No one was spared. June 1961

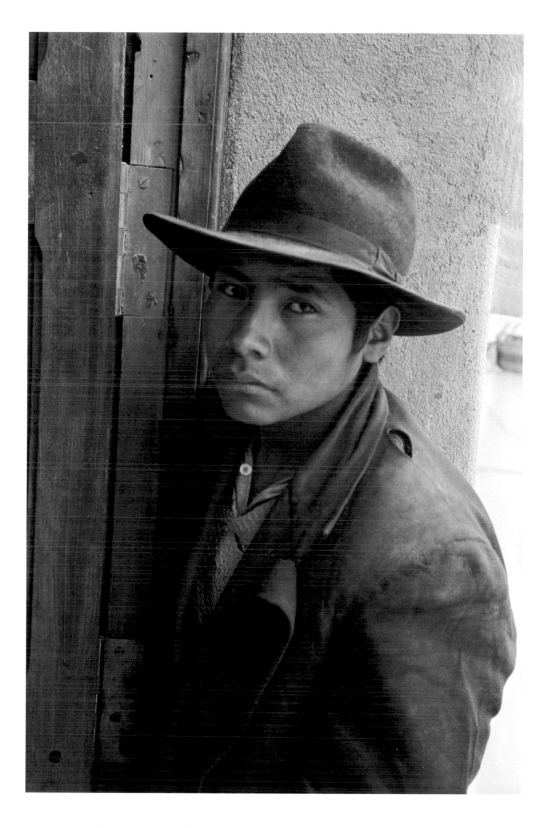

Solemn boy with a hat near the railroad station in Oruro. January 1960

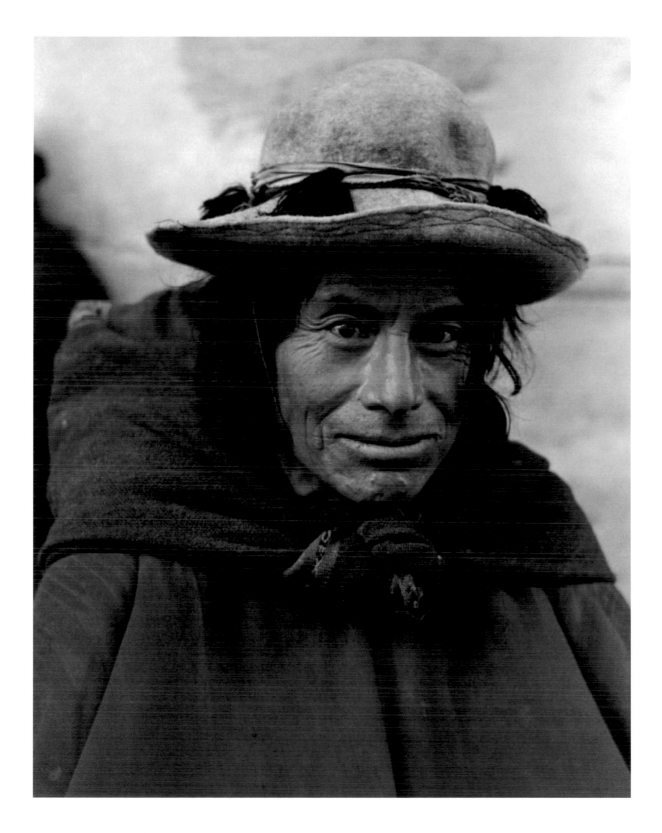

Man from Yamparaez, a village 20 kilometers southeast of Sucre. September 1961

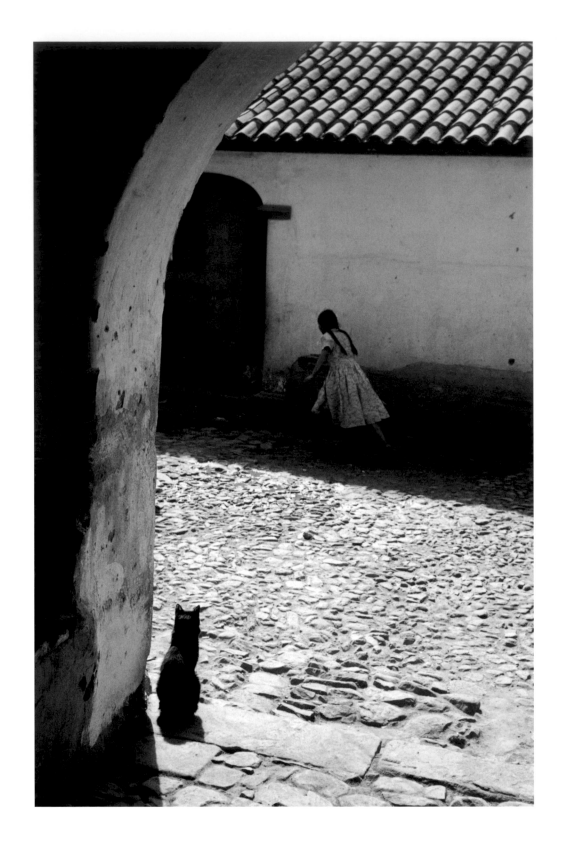

Cat in a doorway. Sucre. June 1960

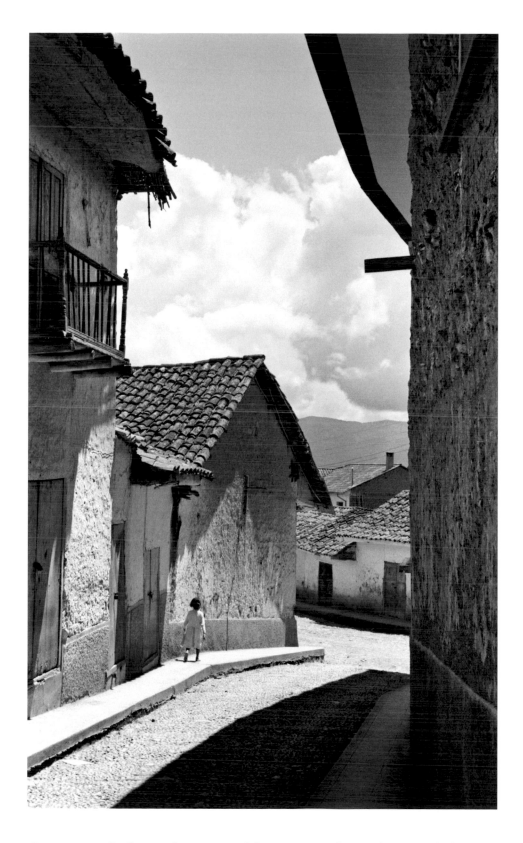

Irupana, a small village in the Yungas 75 kilometers east of La Paz between Chulumani and La Plazuela. The Yungas are semi-tropical, humid valleys in the eastern and lower reaches of the Eastern Andes. At elevations from 3,000 to 5,000 feet their climates are moist and moderate and support abundant tropical agriculture, including coca.

March 1960

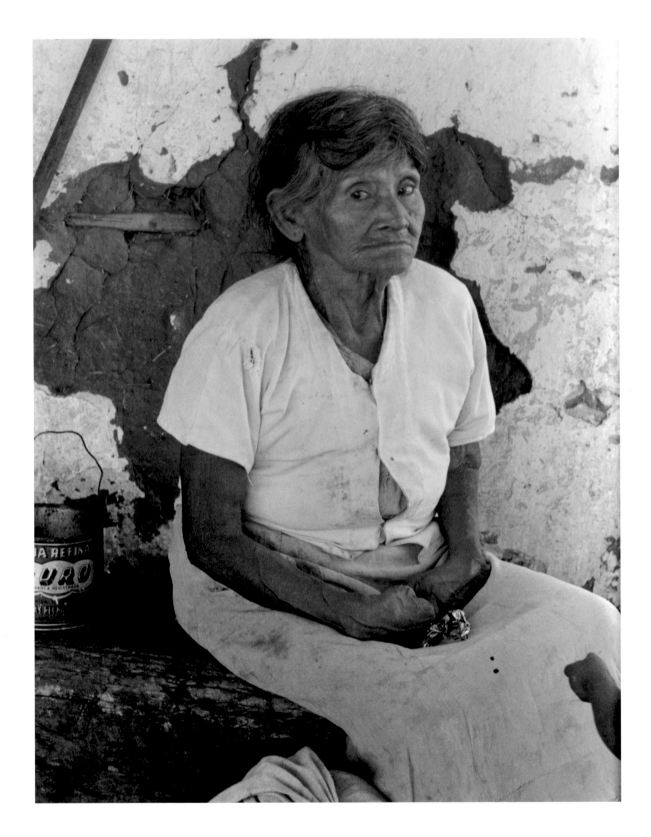

Old lady at railroad station in Roboré. May 1961

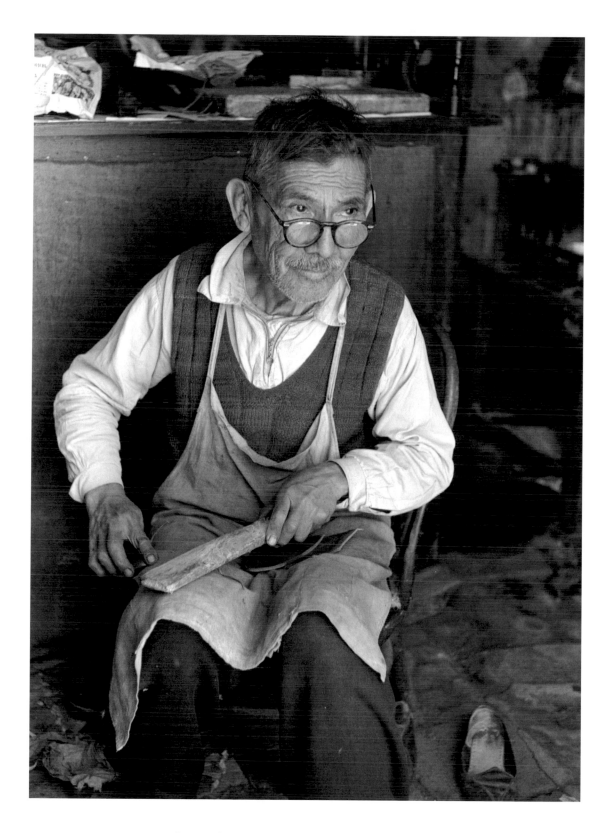

Zapatero (cobbler), Calle San Martín, Cochabamba. October 1961

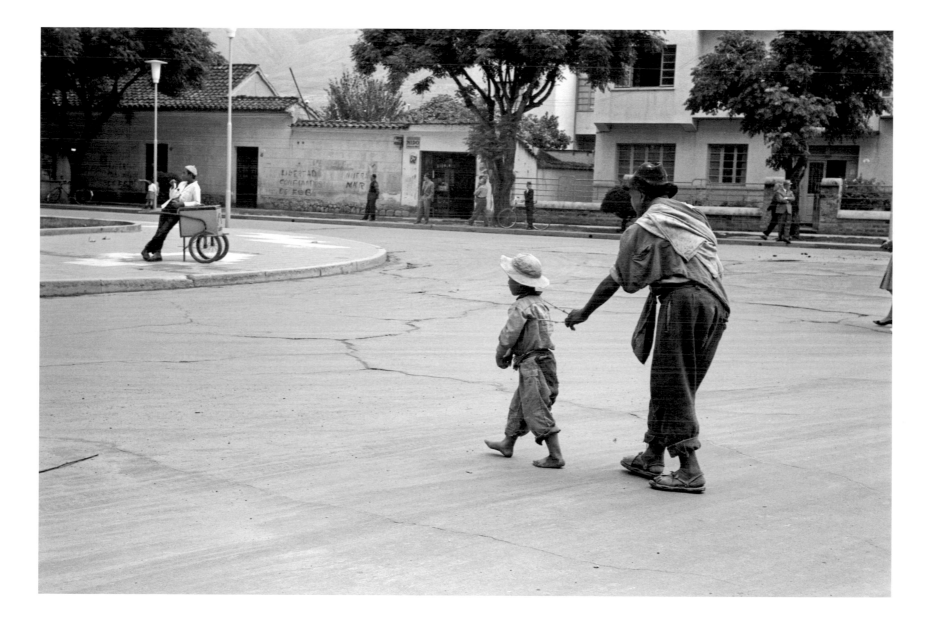

Little boy leading a blind man to the Plaza Colón. Cochabamba.
December 1961

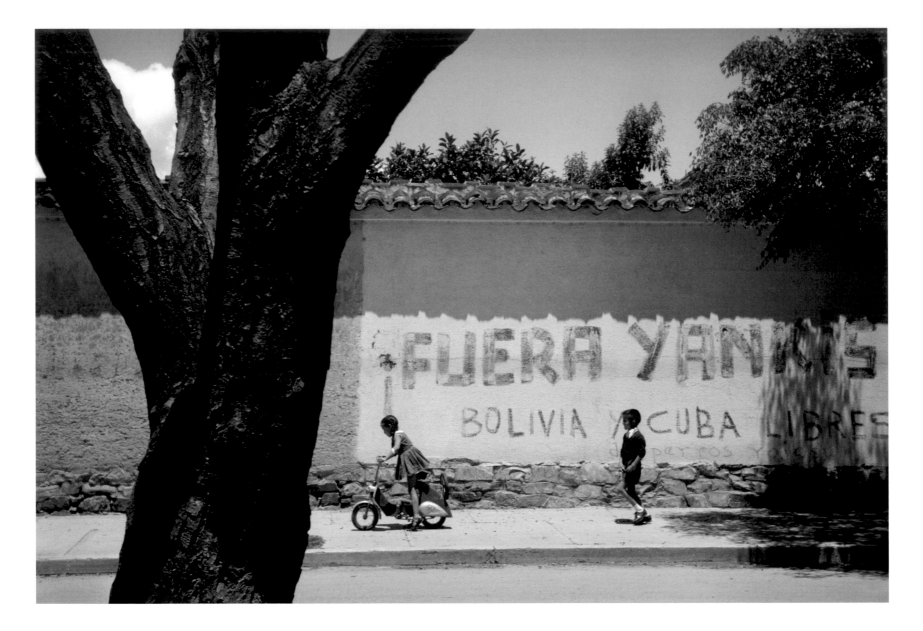

The work of Fidel Castro's people. Note the ironic touch with the kids. Calle Oquendo. Cochabamba.
February 1961

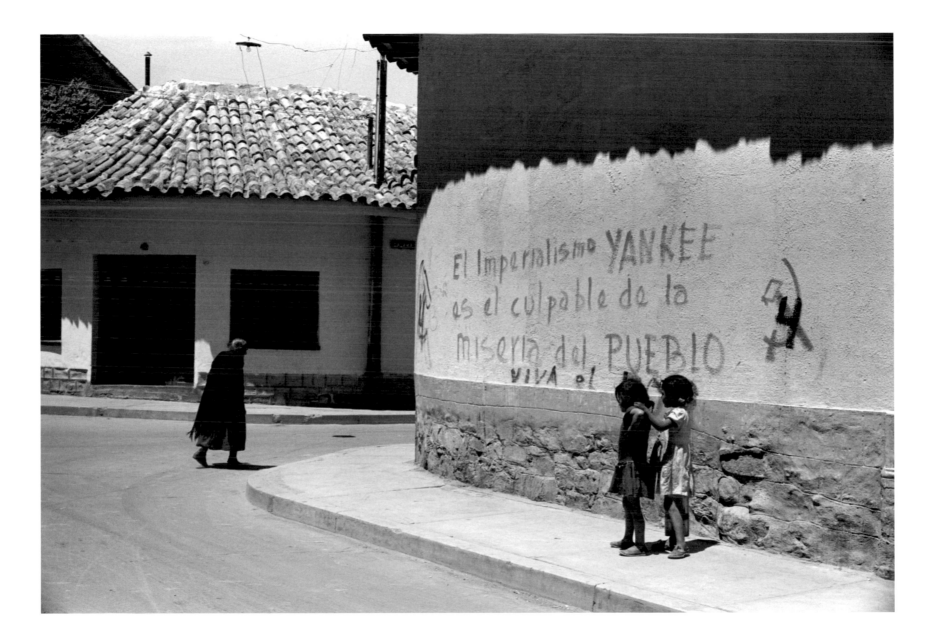

Communist admonishments. This stuff was all over town, this particular example was on Calle Calama, and just a few doors from our office.
Cochabamba. October 1961

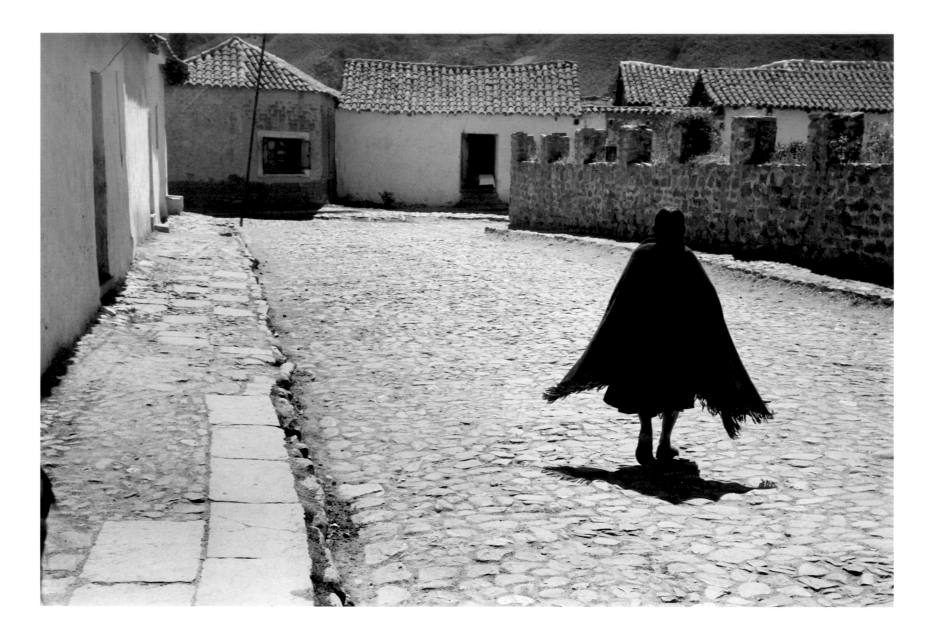

Zudañez at high noon. A small town 60 kilometers east of Sucre.
September 1960

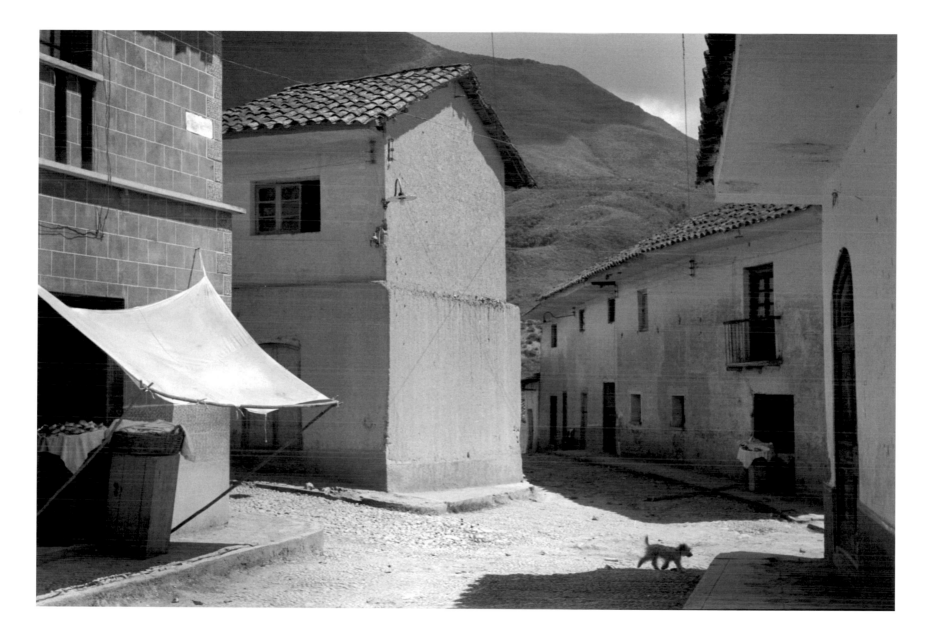

Irupana at high noon. A Yungas town at 3,600 feet elevation and about 75 kilometers east of La Paz.
March 1960

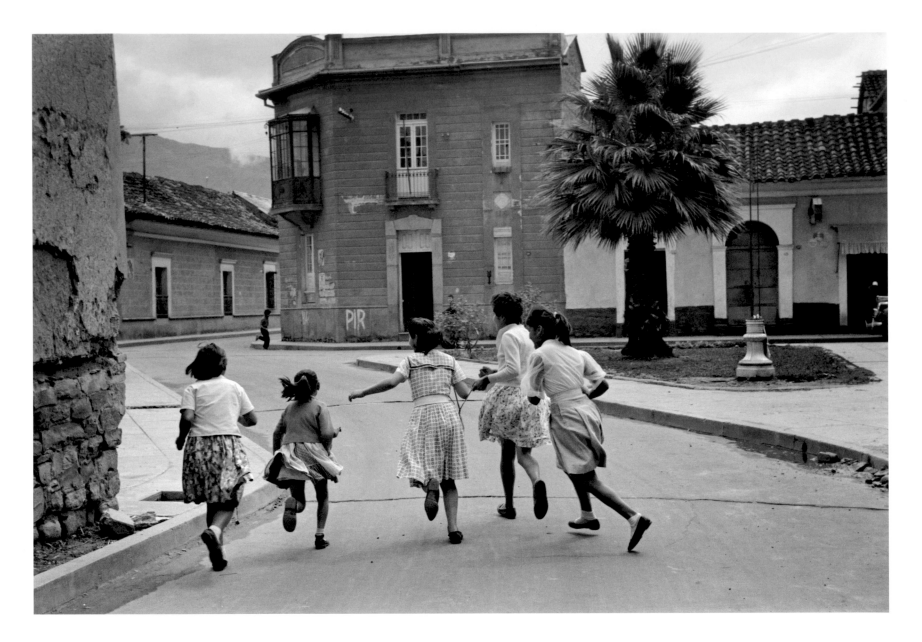

School girls heading home. Cochabamba.
November 1961

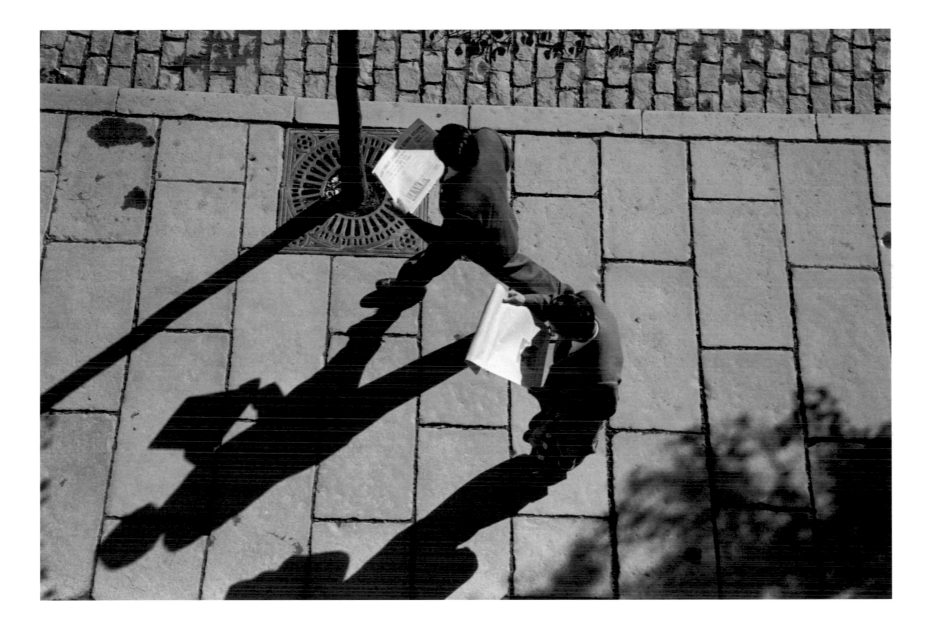

Newspapers, shadows and the morning walk-to-work. Looking down from the Hotel Copacabana onto the Prado after breakfast.
La Paz. January 1960

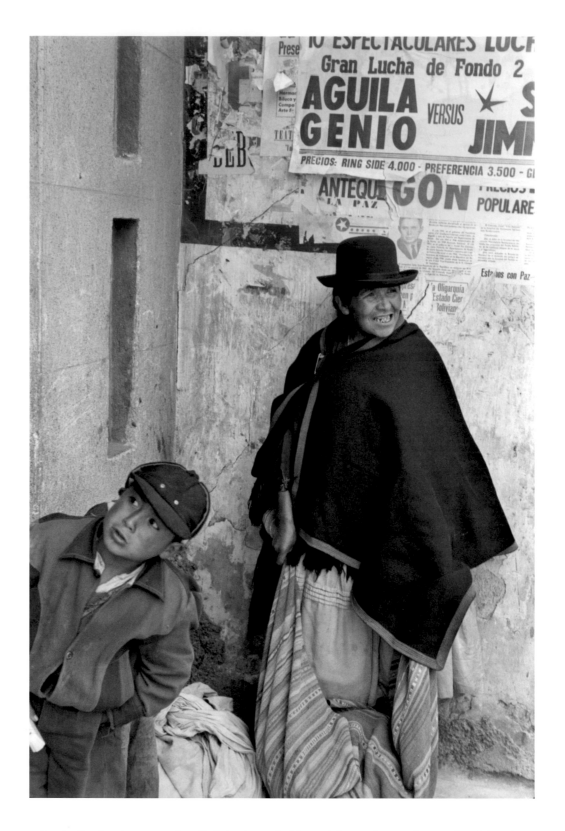

On the Prado, also variously called the Avenida Mariscal Santa Cruz and Avenida 16 de Julio.
La Paz. January 1960

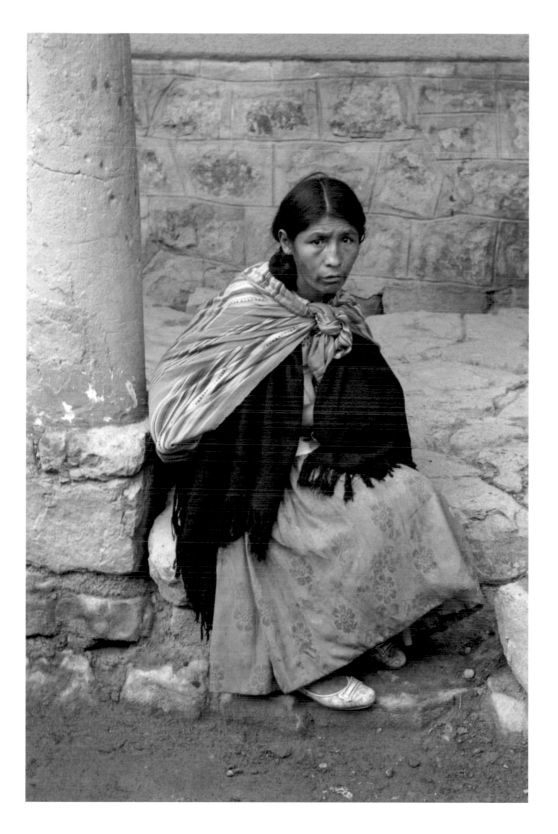

At Quillacollo, a small town ten kilometers west of Cochabamba.
February 1961

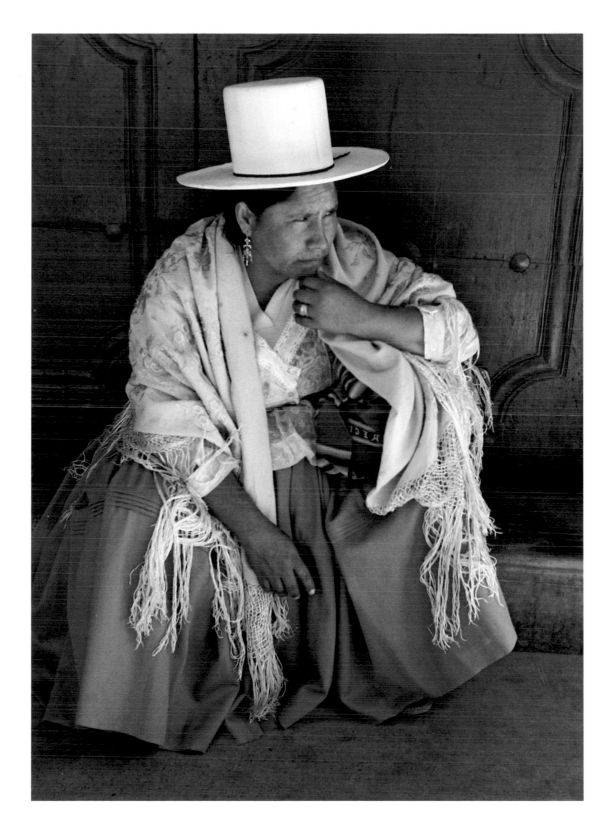

La chola grande. A Quechua lady in full regalia near Plaza 14 de Septiembre, Cochabamba.
The white hat, or taro, is typically Cochabamba.
January 1961

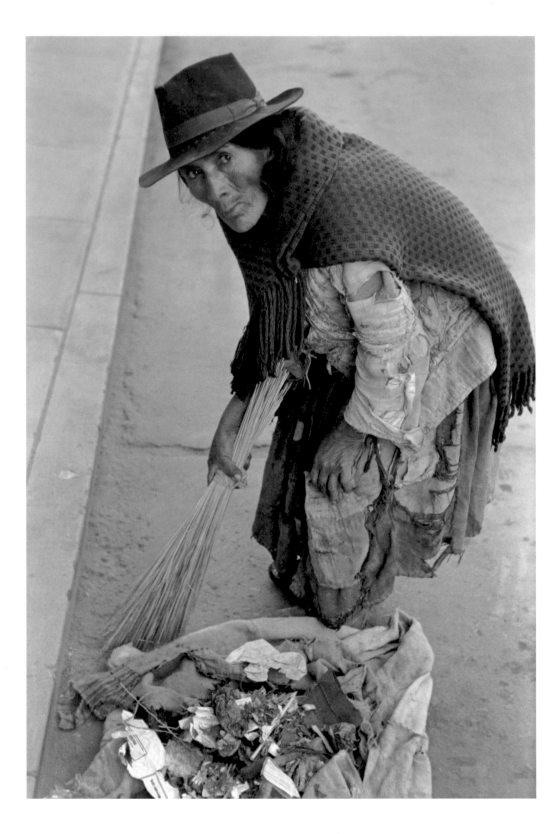

Street sweeper. Sucre. September 1961

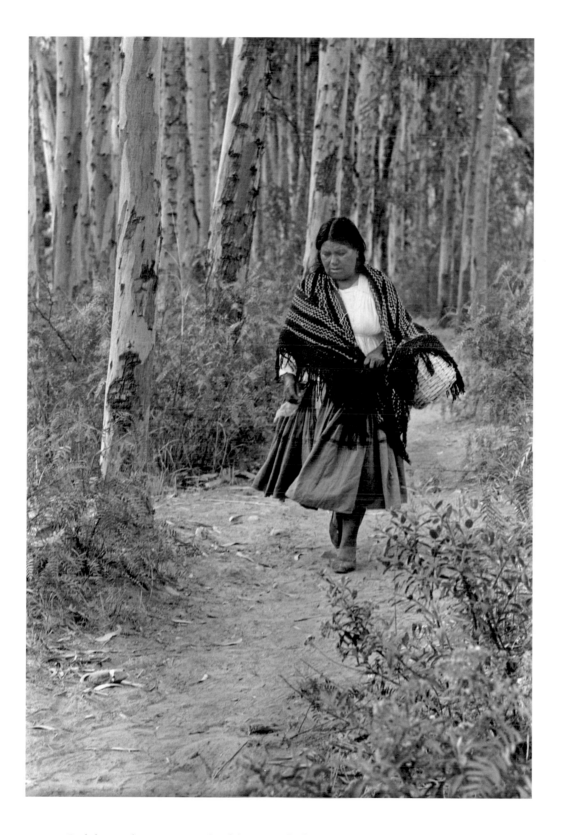

Path by our home just north of the Avenida de Las Américas in barrio Aranjuez.
Cochabamba. October 1961

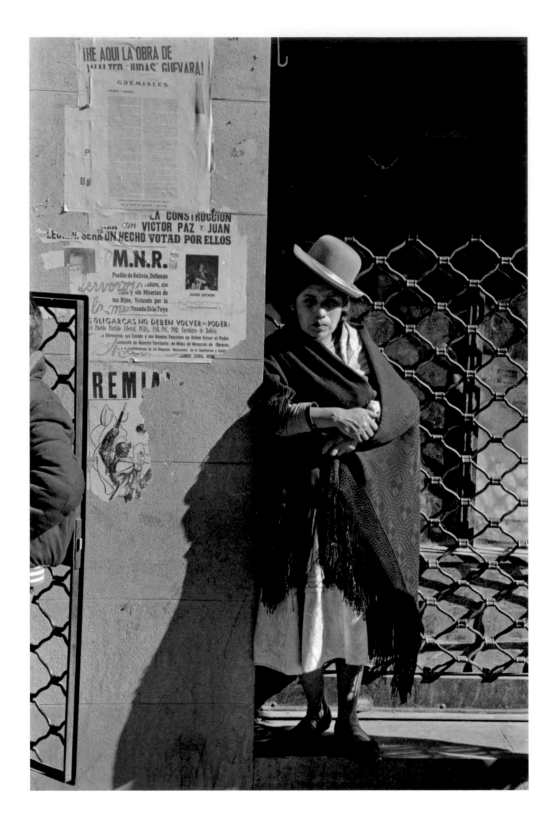

Chola with a cocked derby. Avenida Camacho. La Paz. June 1960

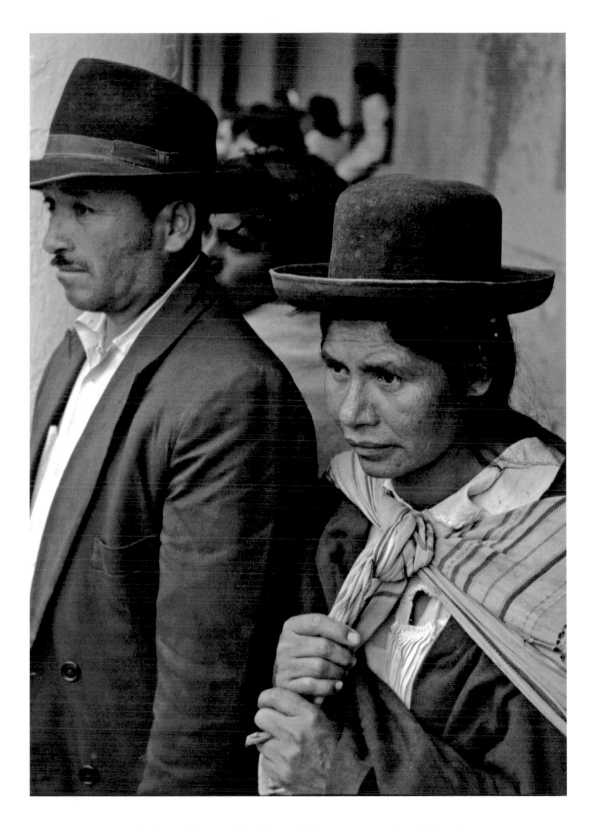

Cholo couple at Quillacollo, ten kilometers west of Cochabamba.
February 1961

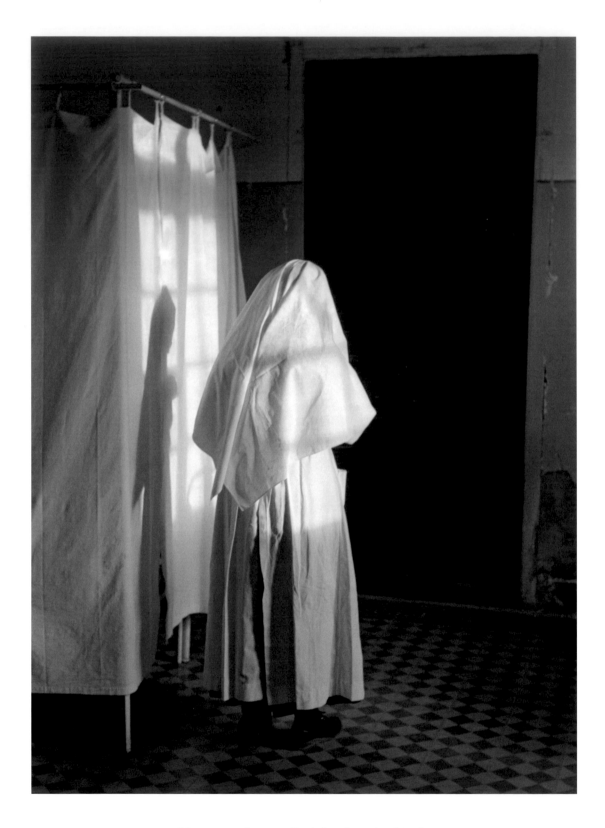

Nurse at orphanage. Cochabamba. April 1961

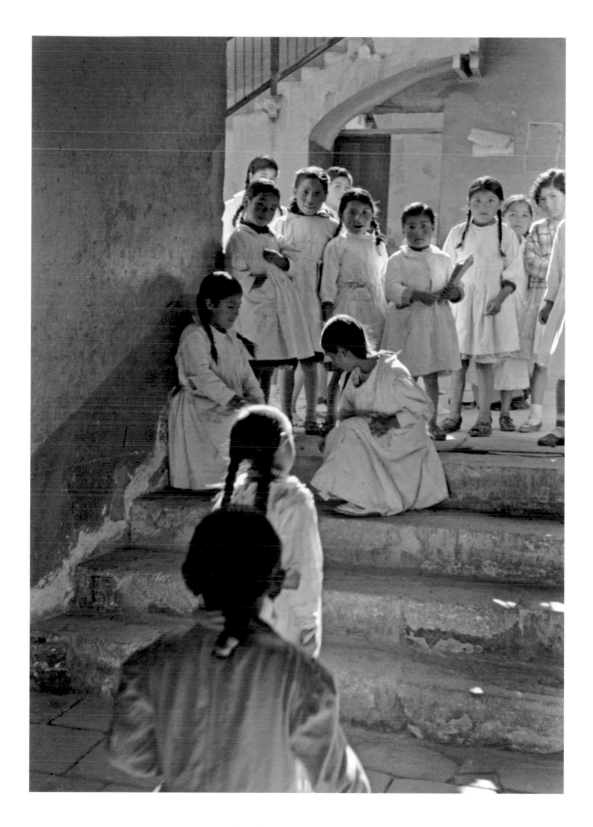

Schoolgirls on steps. Potosí.
September 1961

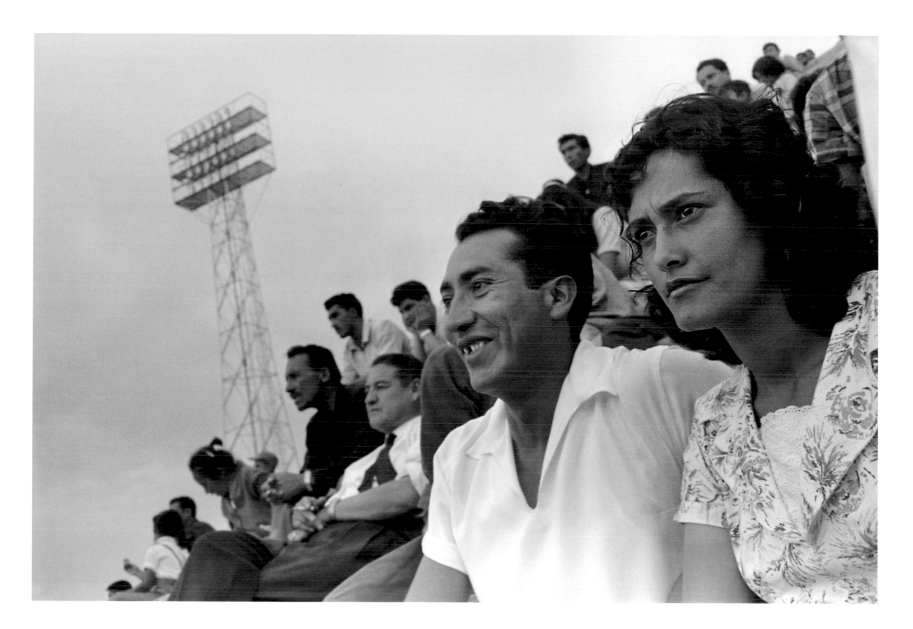

Spectators at a futbol game between Wilsterman of Cochabamba and Dínamo of the Soviet Union. The Russians won—deviously some say—and the Bolivians were not pleased. Instead of having a post-game parade, the Russians had to sneak out of town that night.
Cochabamba. November 1961

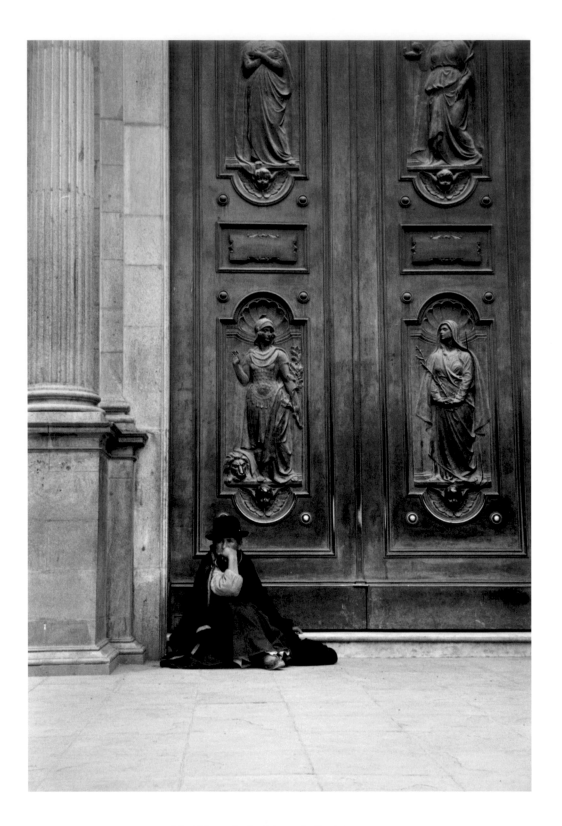

The Elbow Lady, Iglesia de San Francisco.
La Paz. January 1960

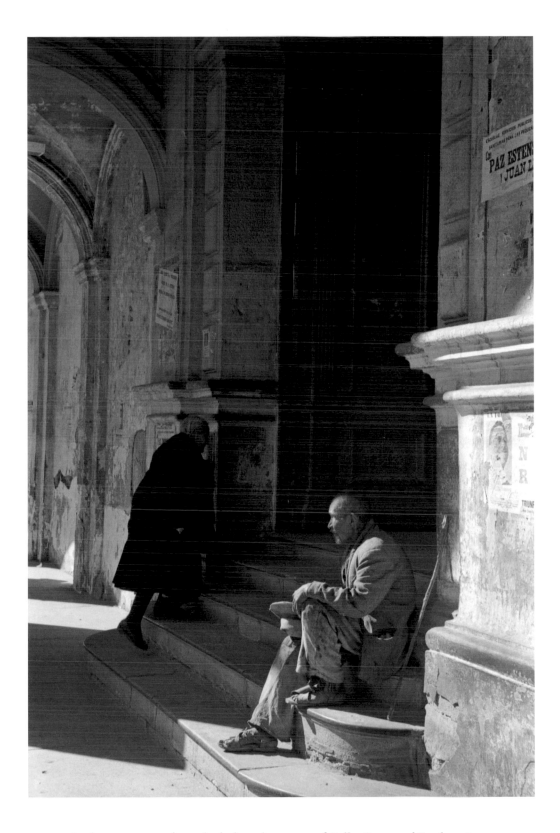

At the entrance to the cathedral on the corner of Calles Sucre and Estéban Arce,
just south of the Plaza 14 de Septiembre.
Cochabamba. June 1960

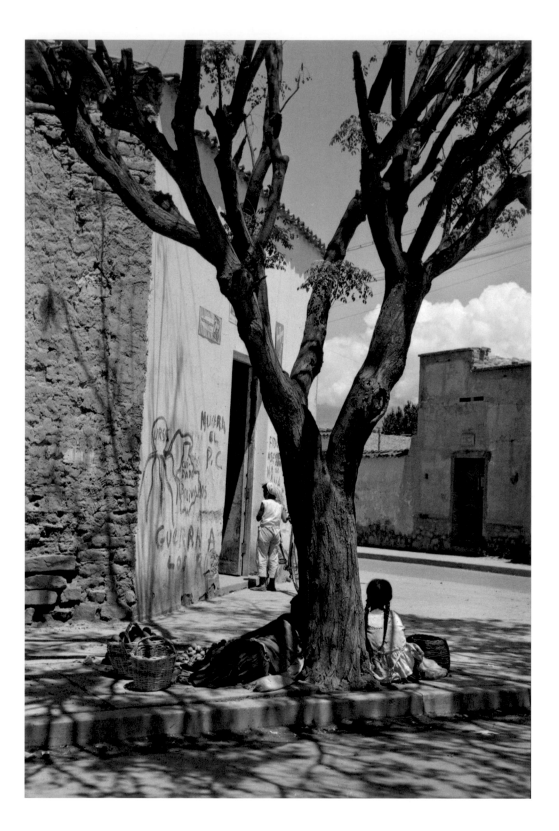

Calle Oquendo. Cochabamba. February 1961

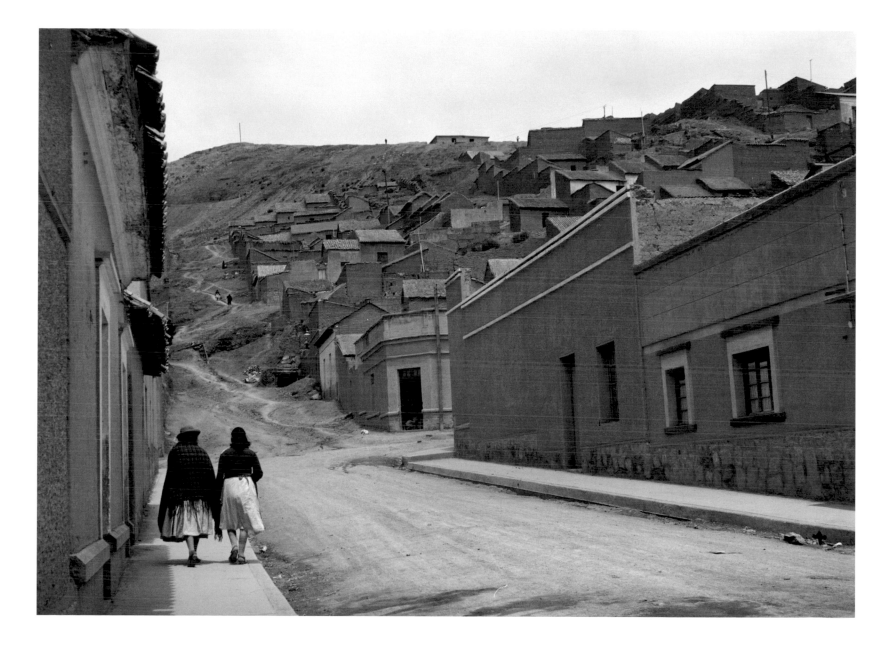

Oruro. January 1960

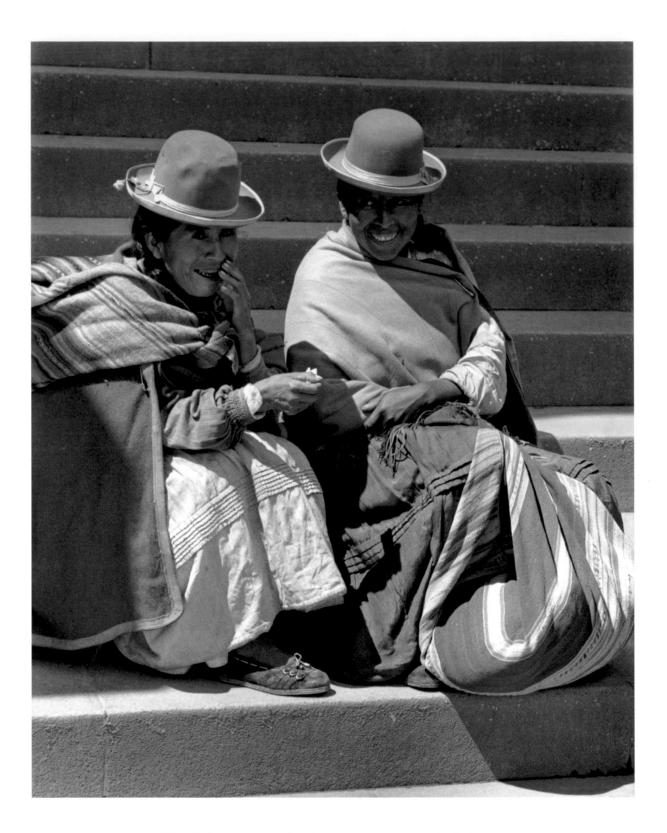

Two cholas enjoying each others company on the cathedral steps.
La Paz. January 1960

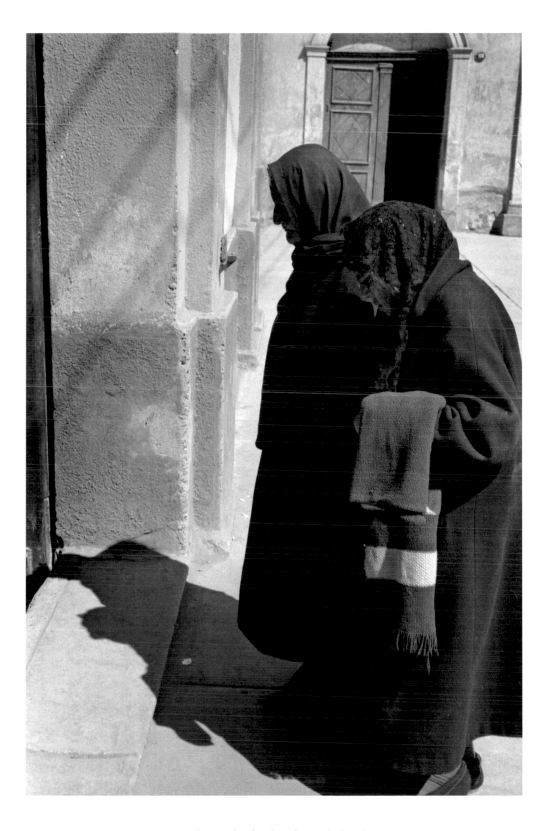

Las dos viudas (widows). Cochabamba.
May 1961

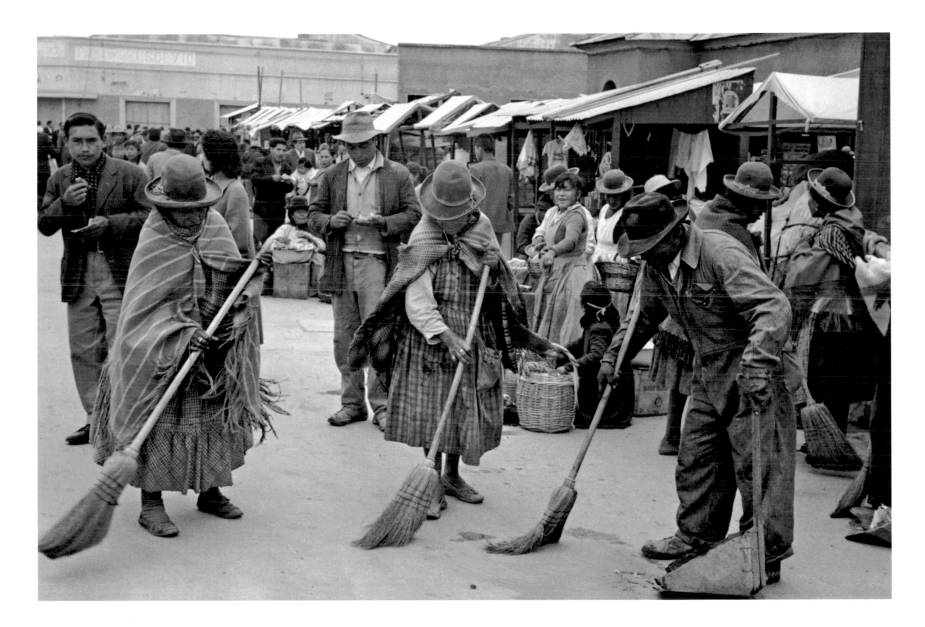

Sweepers in the market place. Oruro. January 1960

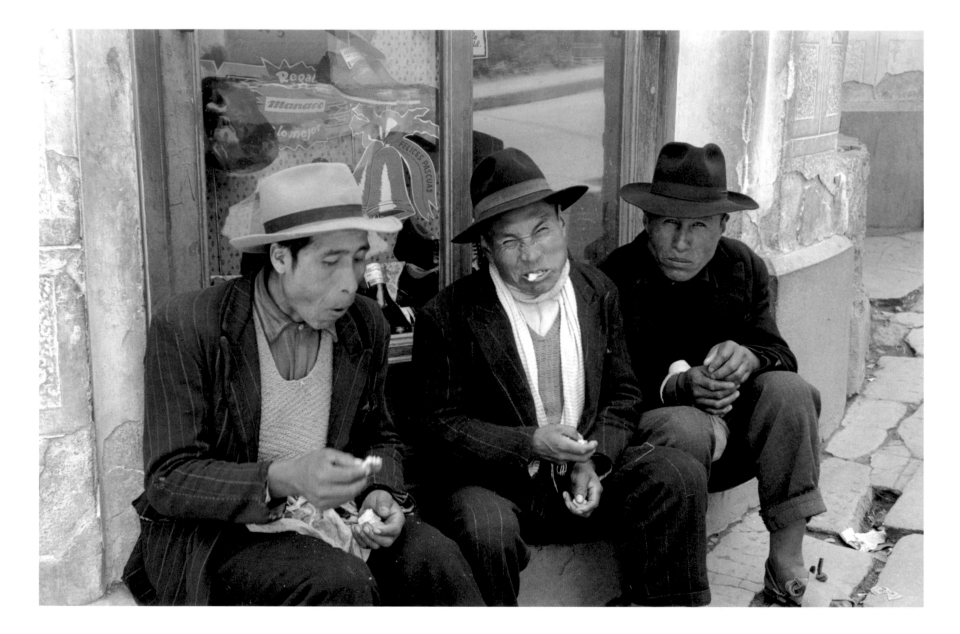

Three men eating and one both eating and grimacing at me. Cochabamba. May 1959

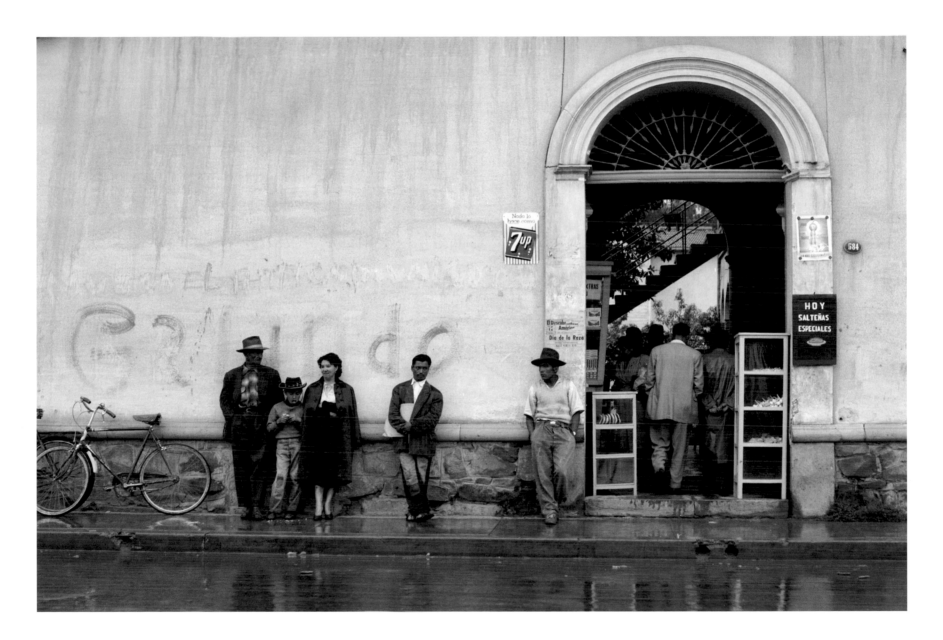

Calle San Martín on eastern side of Plaza Colón. Cochabamba. December 1959

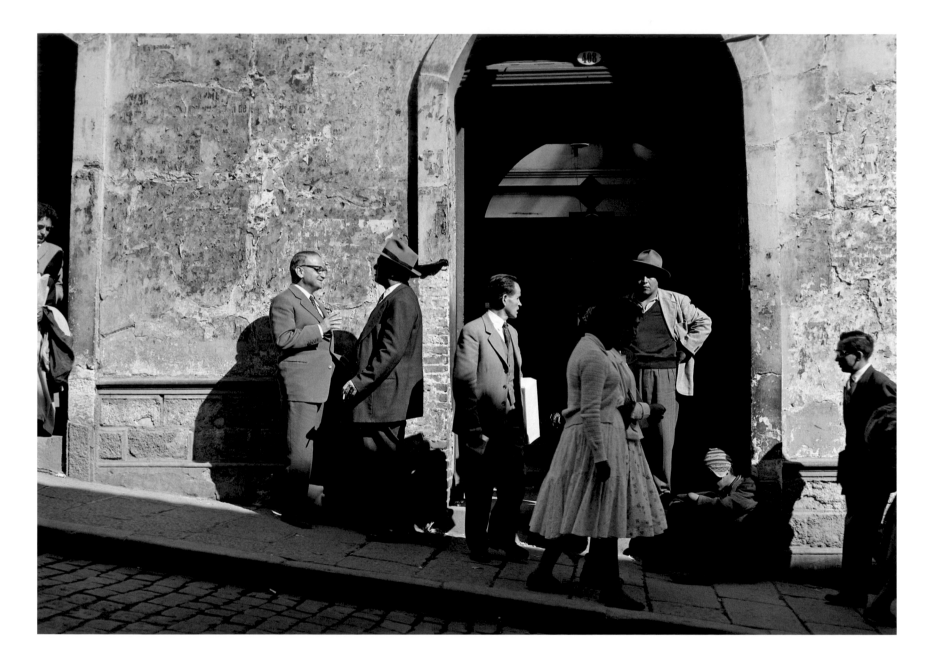

Post Office. La Paz. January 1960

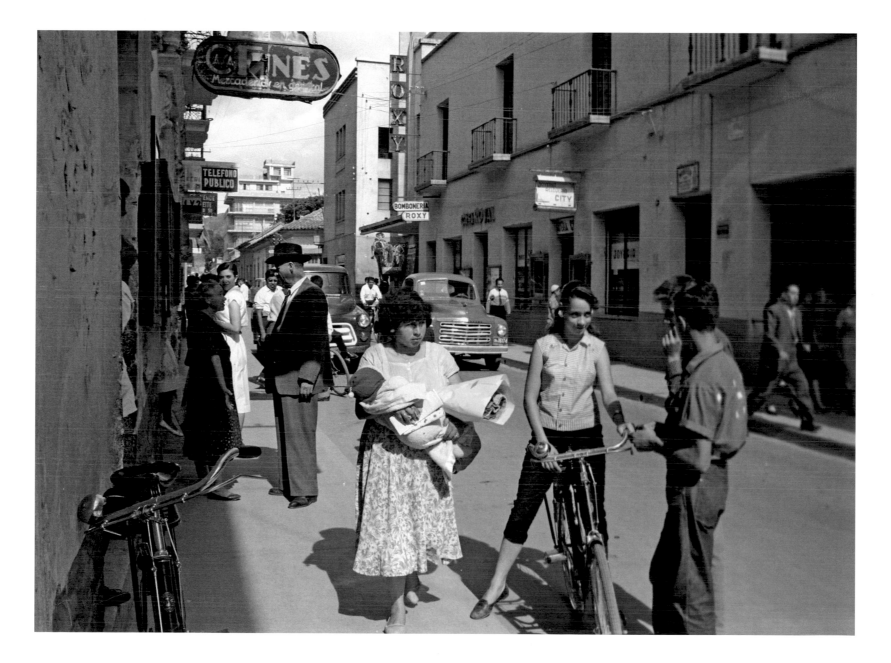

A young man charming his bicycle-riding friend. A bit of middle-class Bolivia. Avenida Libertador Bolívar, near Calle España.
Cochabamba. January 1960

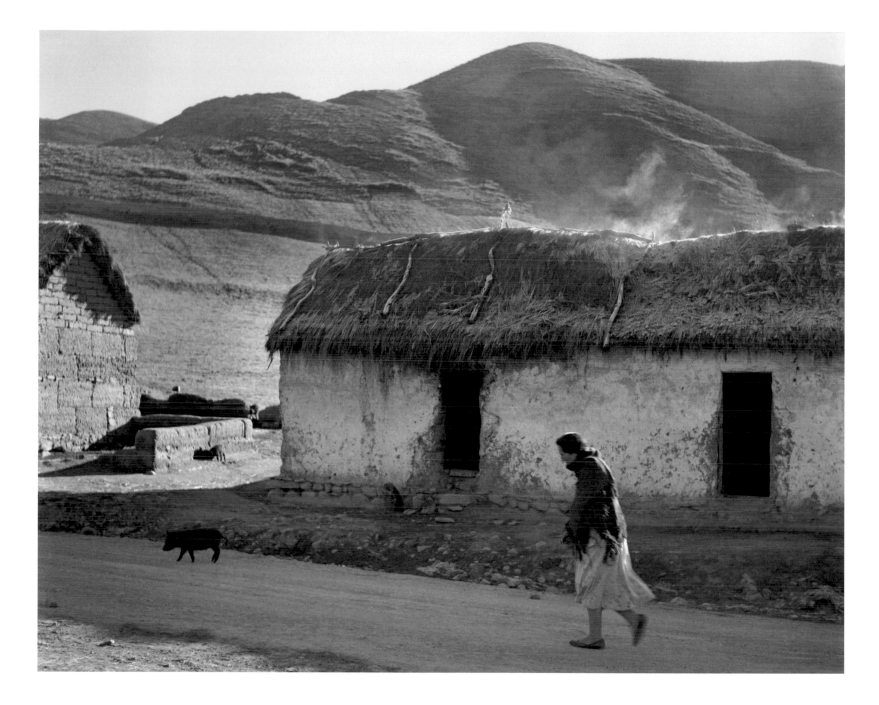

Challa, about 60 kilometers northeast of Oruro on the Cochabamba-Oruro road
where the Eastern Andes begin to flatten into the Altiplano. March 1960

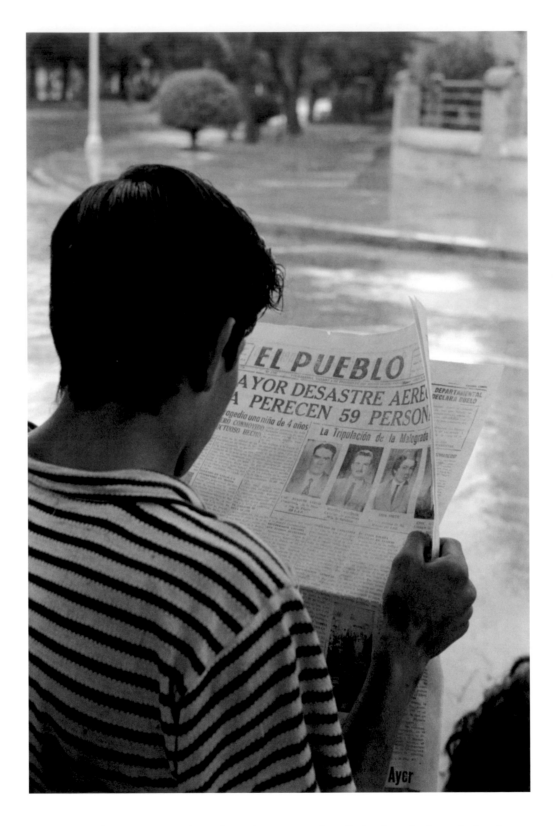

Man reading newspaper about the early morning plane for La Paz which crashed and
killed 59 people including one company family on the way to La Paz.
Cochabamba. January 1960

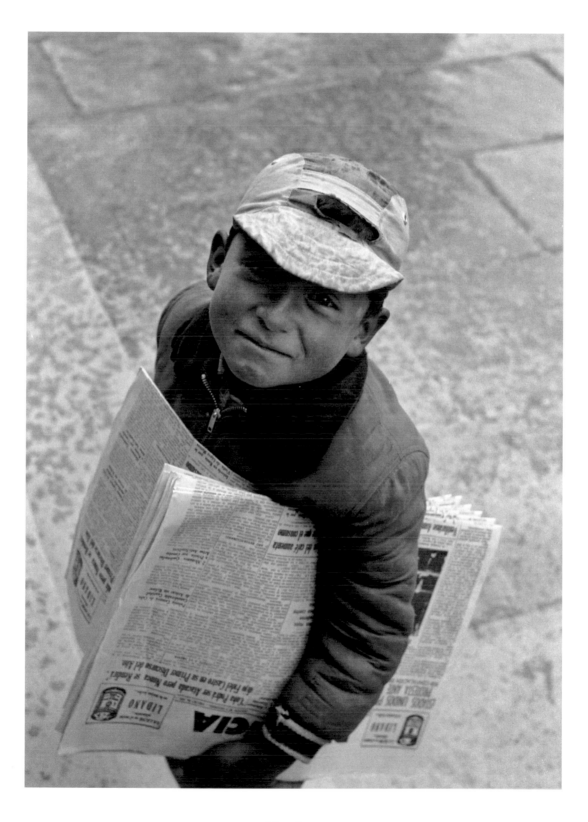

Newsboy.
La Paz. January 1960

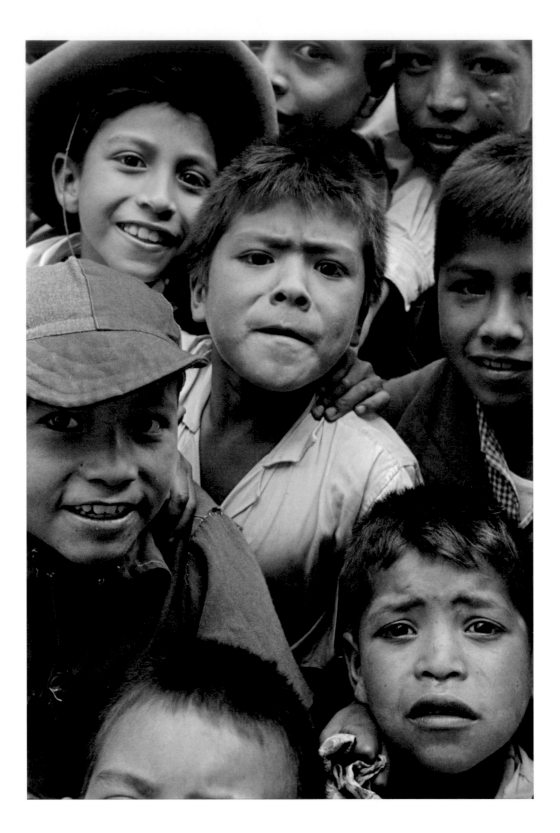

Eager little boys who seemed curious about me.
Calle Ecuador. Cochabamba. December 1961

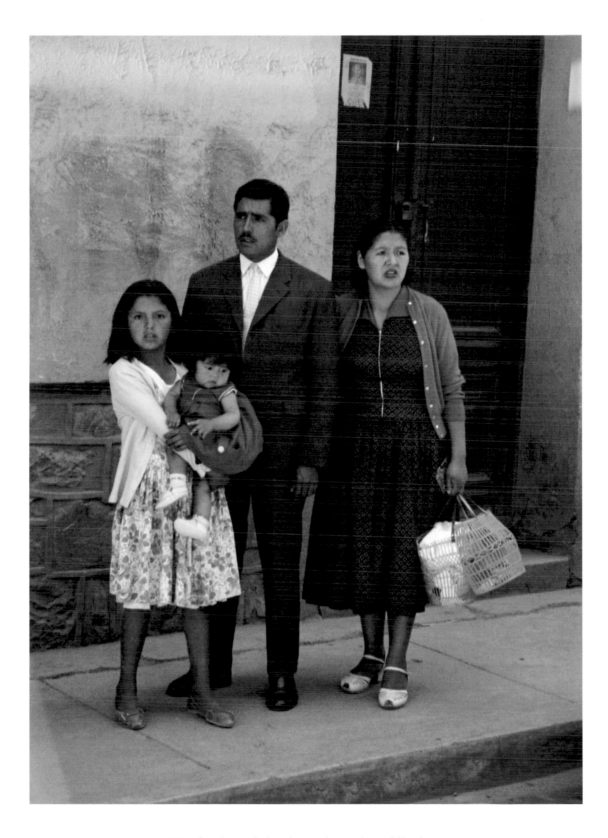

Una familia cochabambina, obviously middle-class.
Avenida 25 de Mayo. Cochabamba. December 1961

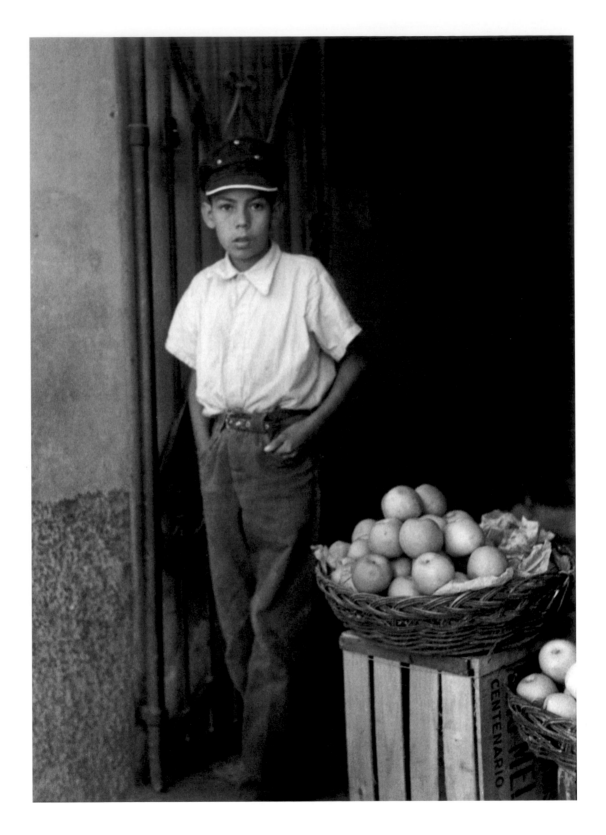

Boy selling apples near Plaza 14 de Septiembre. Cochabamba. May 1959

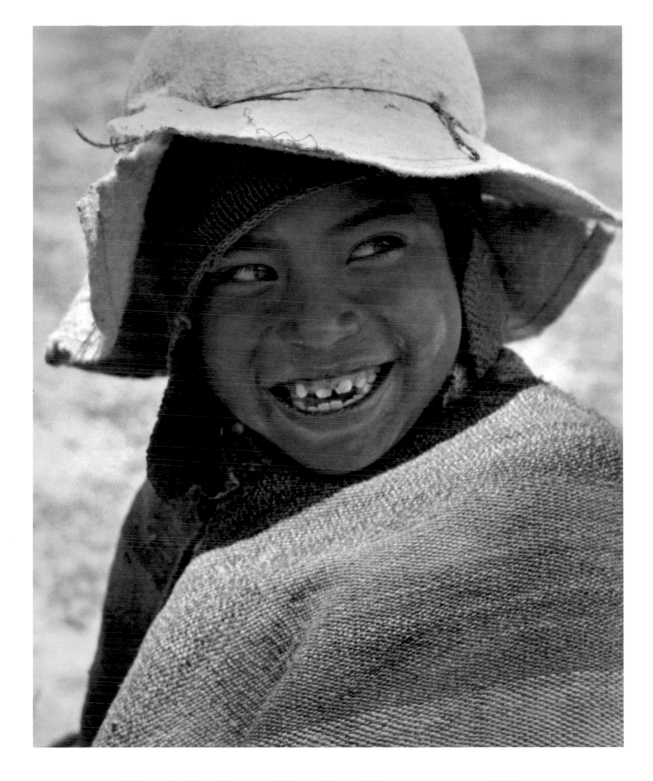

Chiquitín. One of a group of Aymara boys who'd visit our camp near Challa,
between Leque and Lequepalca, especially around breakfast. They were very partial to strawberry jam,
at that time Cochabamba's principle canned product. Challa. March 1960

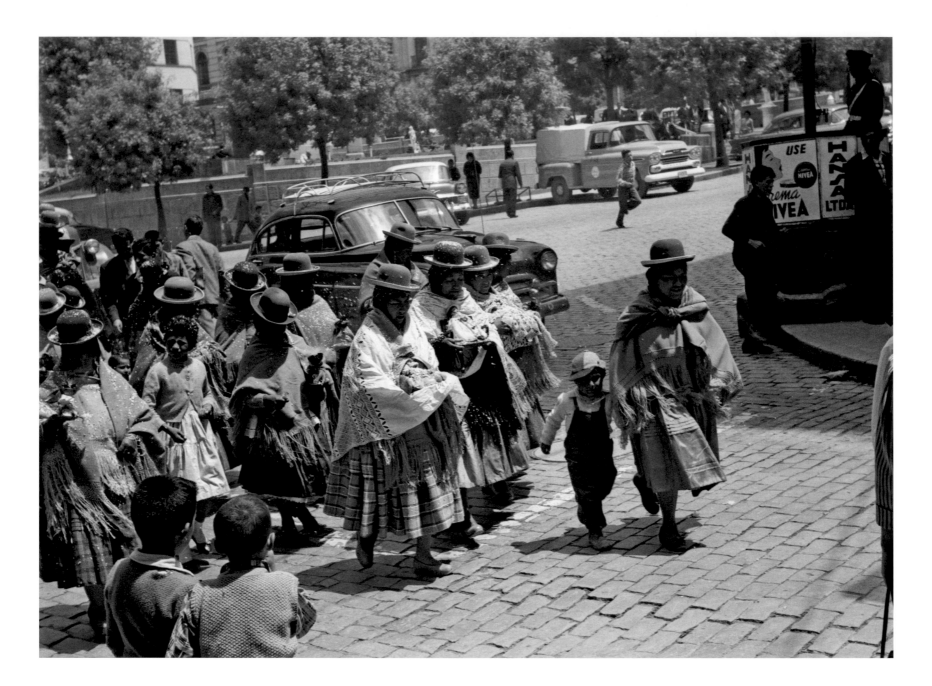

A group of cholas. La Paz. January 1960

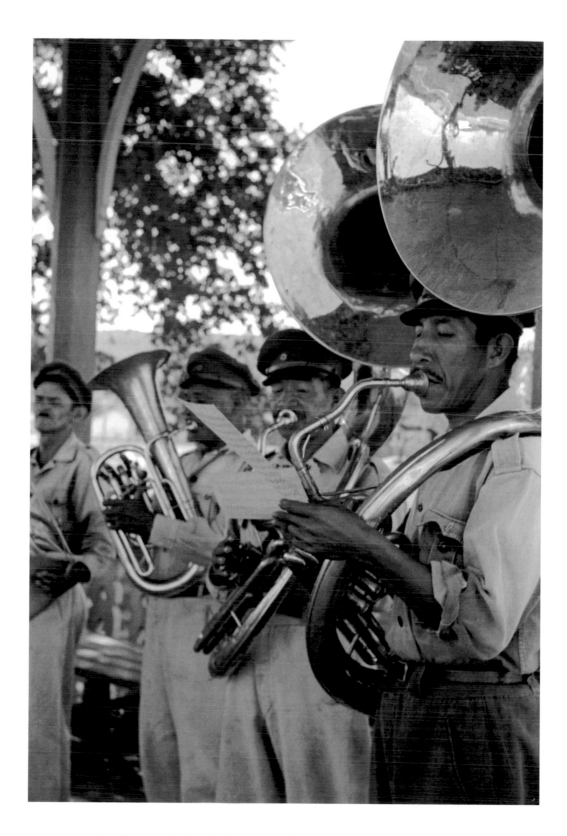

Low brass in the banda de musica at the army barracks giving a concert
in the plaza, just a short distance from the Alojamiento where we lived. Roboré.
May 1961

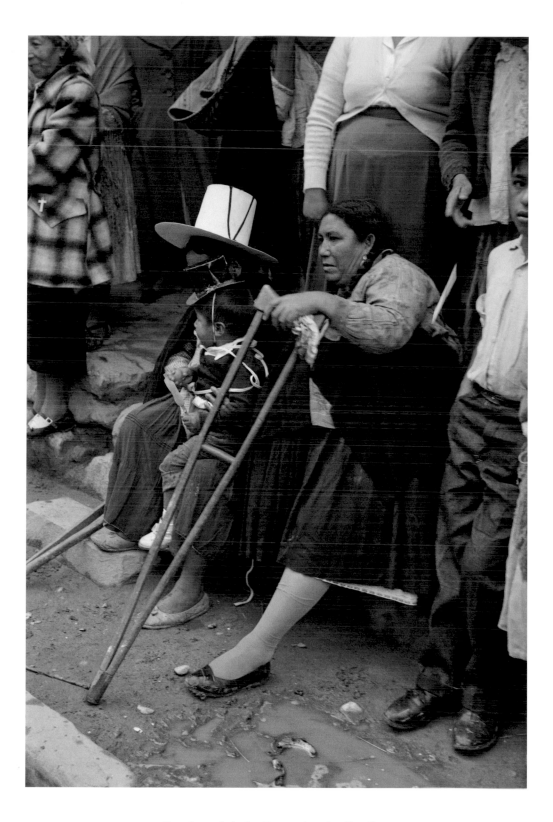

One-legged chola. Carnival at Quillacollo.
February 1961

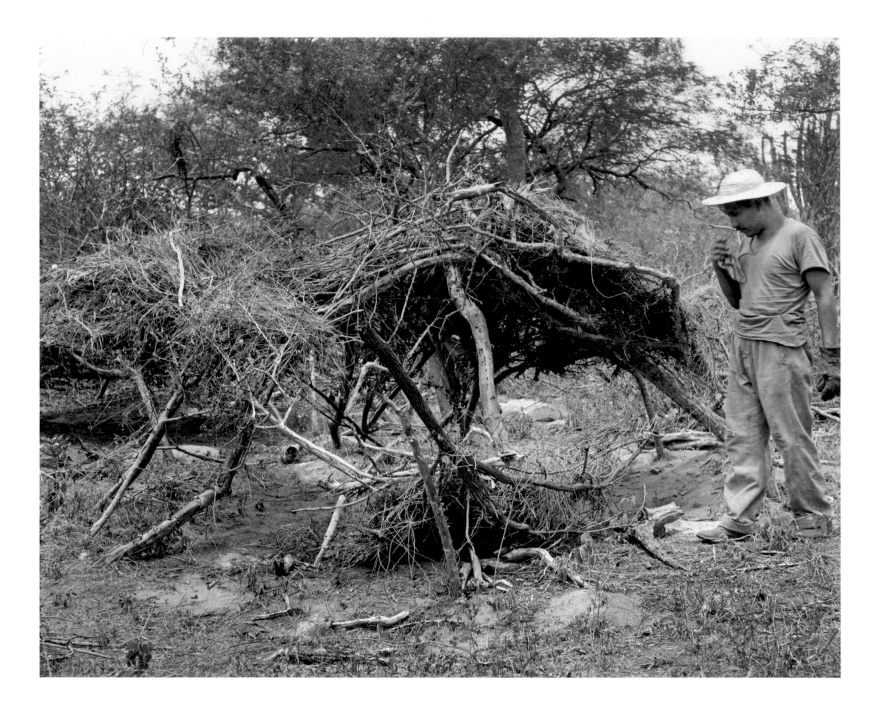

This structure and others like it were built by the Ayoreos aboriginals, about 30 kilometers east of Cerro Capital Ustares. The function of these structures is unclear; perhaps they are dwellings of some sort, as warm ash was reported in some of them. Or, perhaps, as Julian Duguid reported in 1931, they were built to attract the travelers who would then be attacked.
October 1960

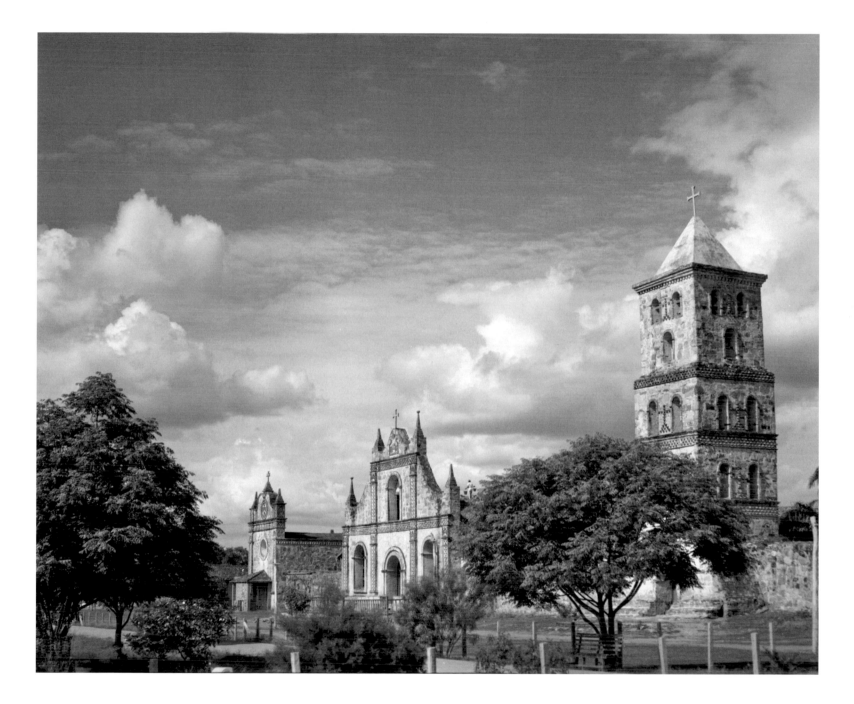

Jesuit church in San José de Chiquitos dating from the mid-eighteenth century.
November 1959

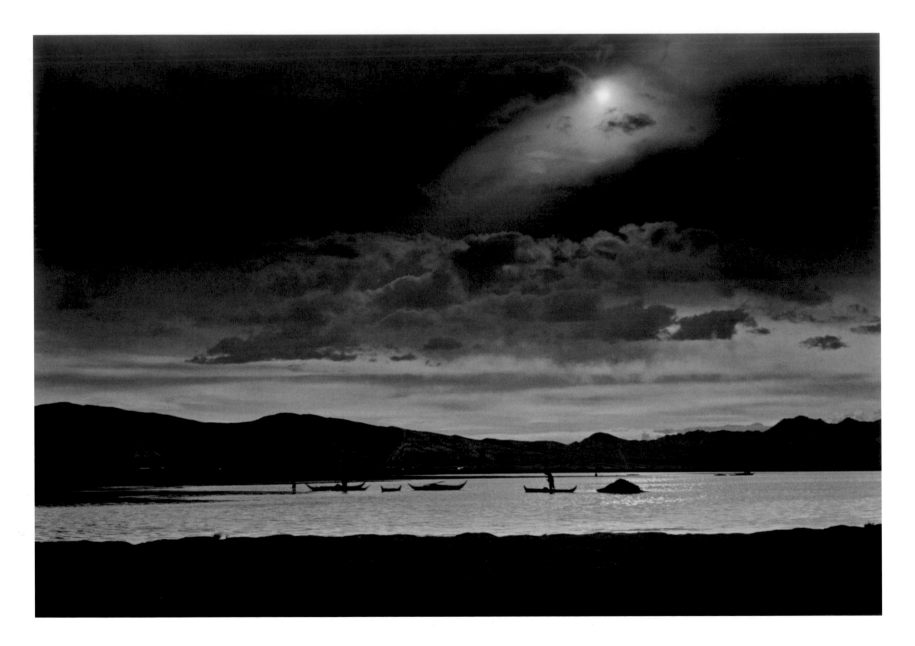

Lake Titicaca, looking north from the SS Ollanta in the port of Guaqui at the southernmost extreme of
Lake Titicaca (elevation 12,230 feet above sea level).
January 1962

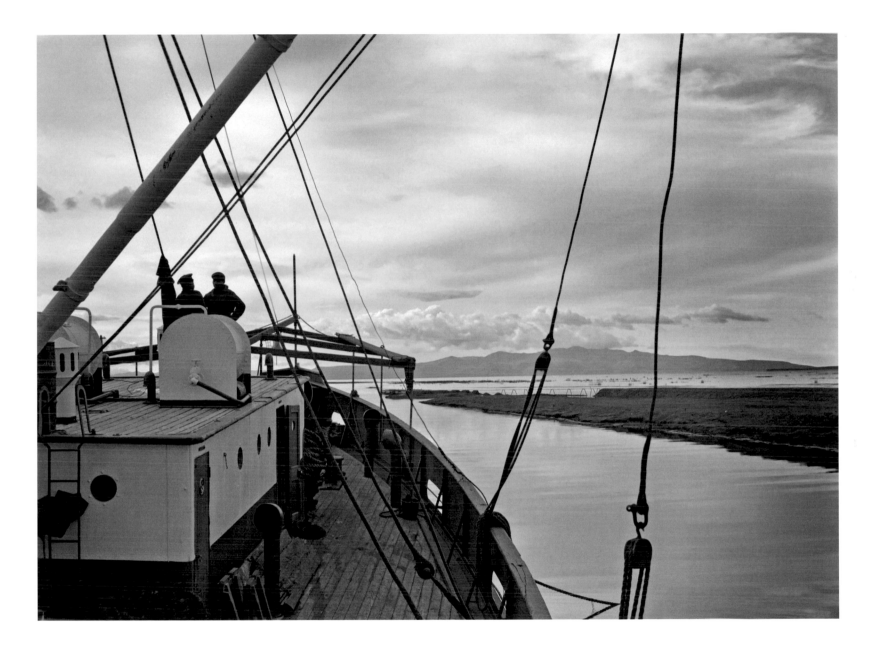

Taken from the SS Ollanta, last steamer on Lake Titicaca, in the Bolivian port of Guaqui at the southern end of the lake.
Launched in Titicaca in the 1930s, the ship, owned by the Peruvian navy, is still in business.
January 1962

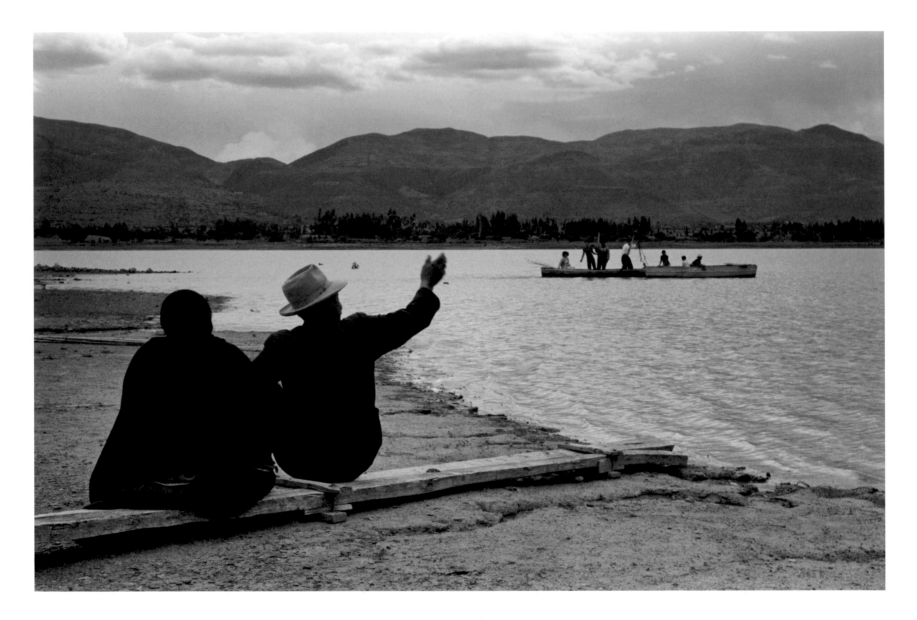

Laguna Angustura near Cochabamba.
January 1962

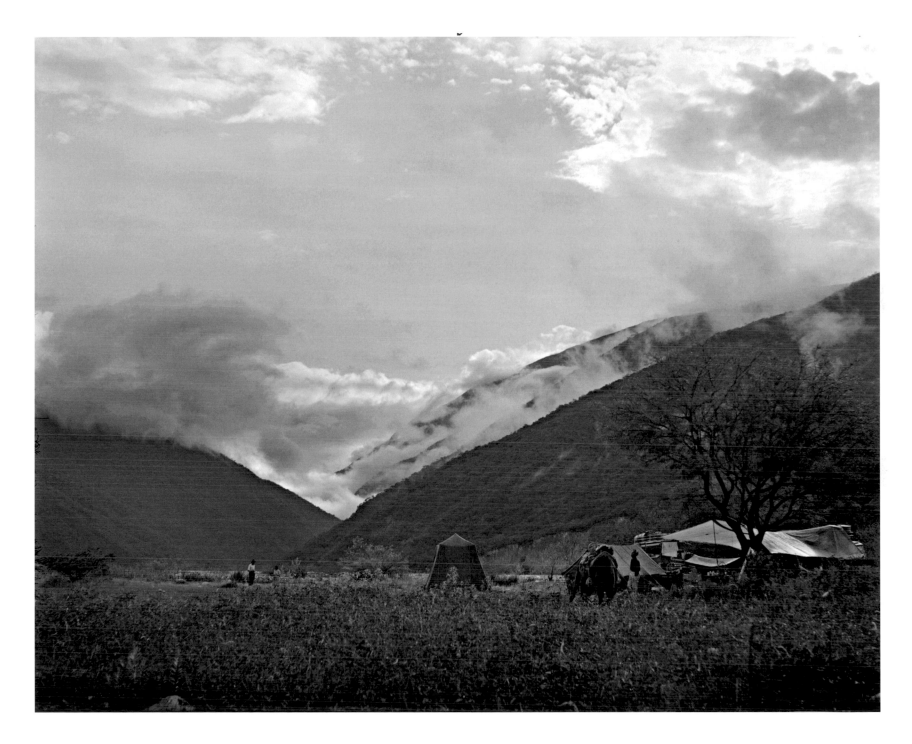

Our field camp near La Plazuela on the Río Bopi, some 75 kilometers east of La Paz and 8,300 feet lower. March 1960

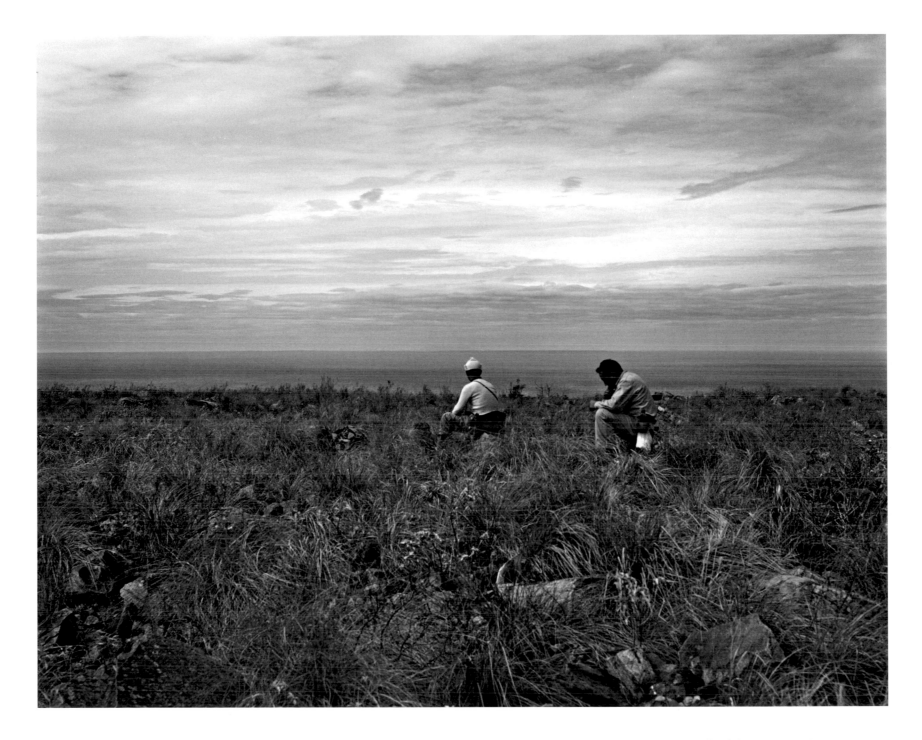

Looking to the east from the flat summit of Cerro San Miguel, about 175 kilometers southwest of Roboré and a few kilometers north of the Paraguayan border. Cerro San Miguel rises above its surroundings by about a 1,000 meters. The weather, however, was threatening and my altimeter was affected by it. The horizon is probably several hundred kilometers away. The Andes could also be seen from Cerro San Miguel as a smudge on the horizon about 350 kilometers to the west. My companions were Eduardo Olmos and Raúl Padilla on the right. October 1960

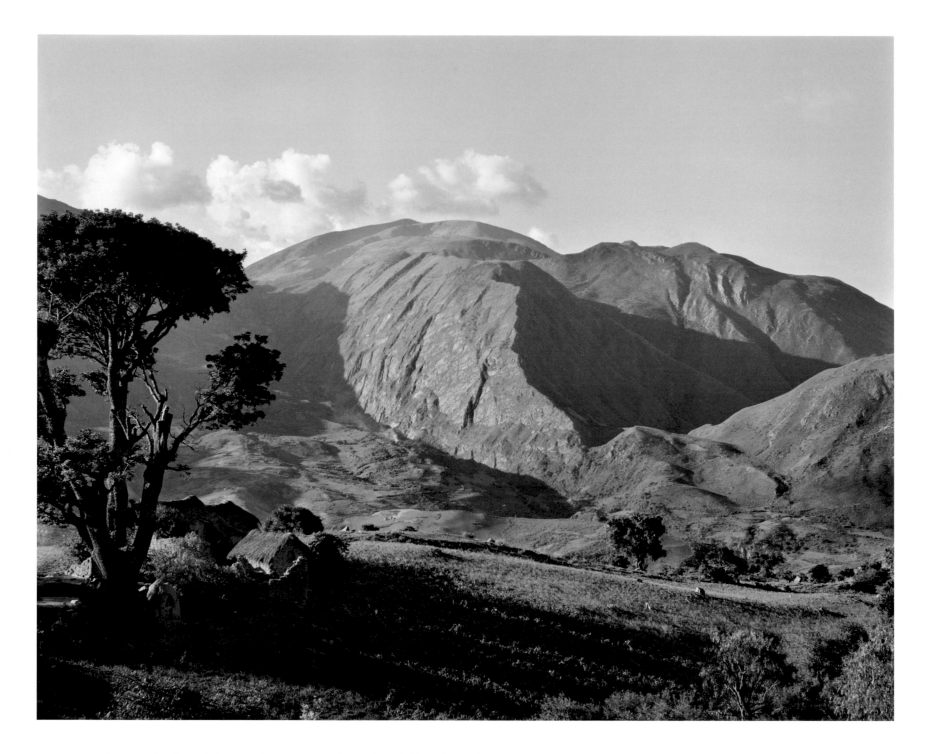

The curved and eroded crest of the Pojo anticline, a large fold in the Ordovician quartzite, just north of the Cochamba-Santa Cruz highway between the Pojo and Copachuncha valleys. January 1961

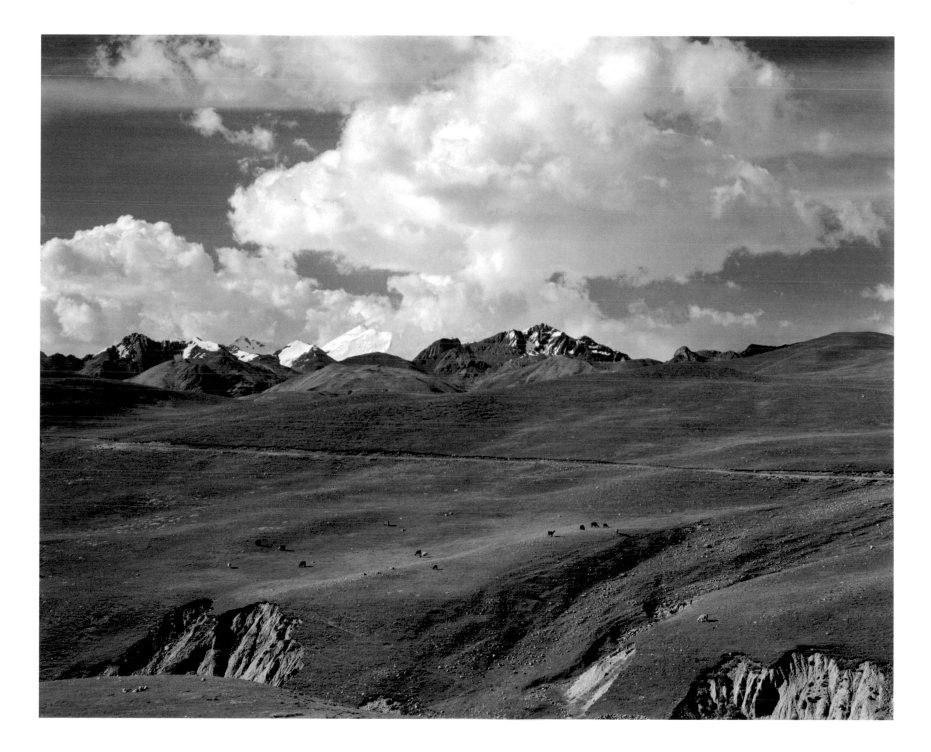

The Cordillera de Tres Cruces between the Altiplano and Quime about 100 kilometers southeast of La Paz.
Elevations run between 13,000 and 16,000 feet. March 1960

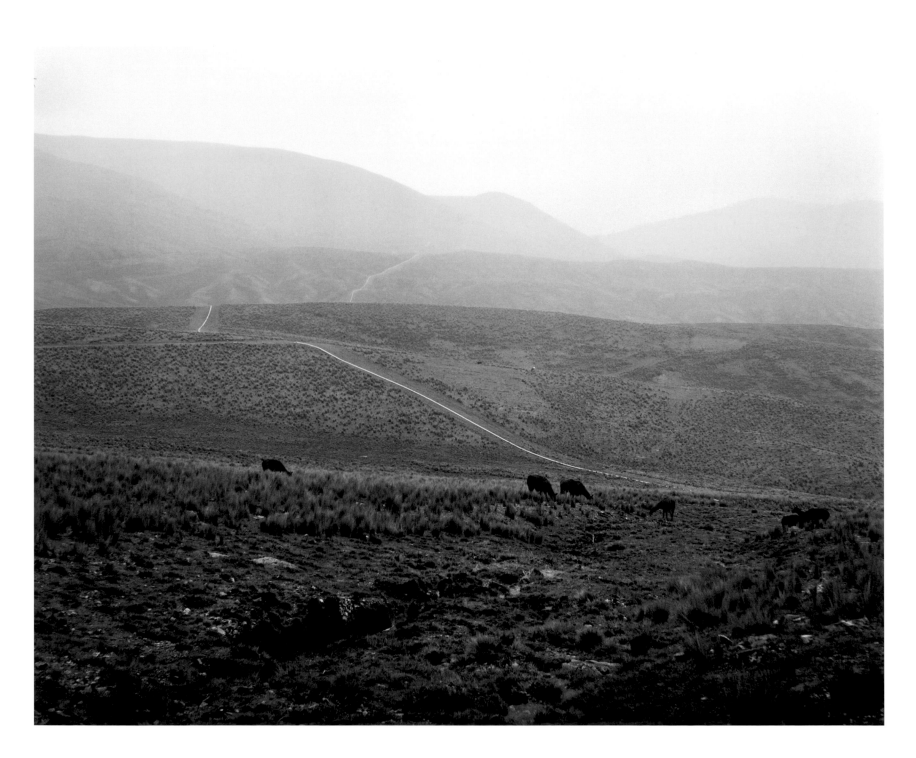

Oil pipeline in the area of Condor Pass on the road between Cochabamba and Oruro. January 1960

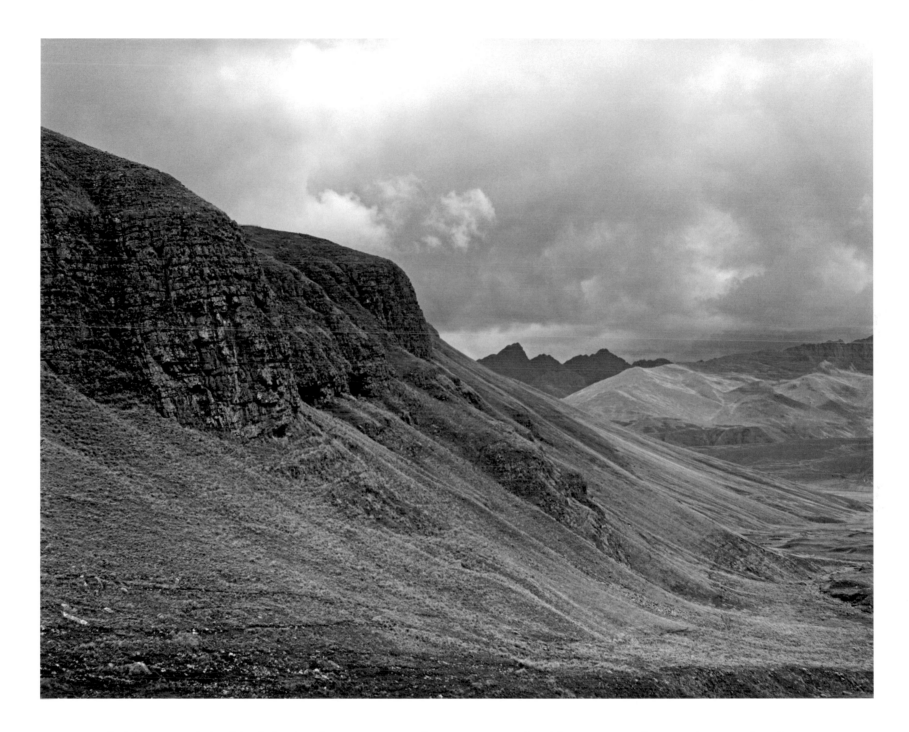

The Tunari range behind Cochabamba. Elevations are around 12,000 to 15,000 feet. The strata are Ordovician siltstone and sandstone.
December 1959

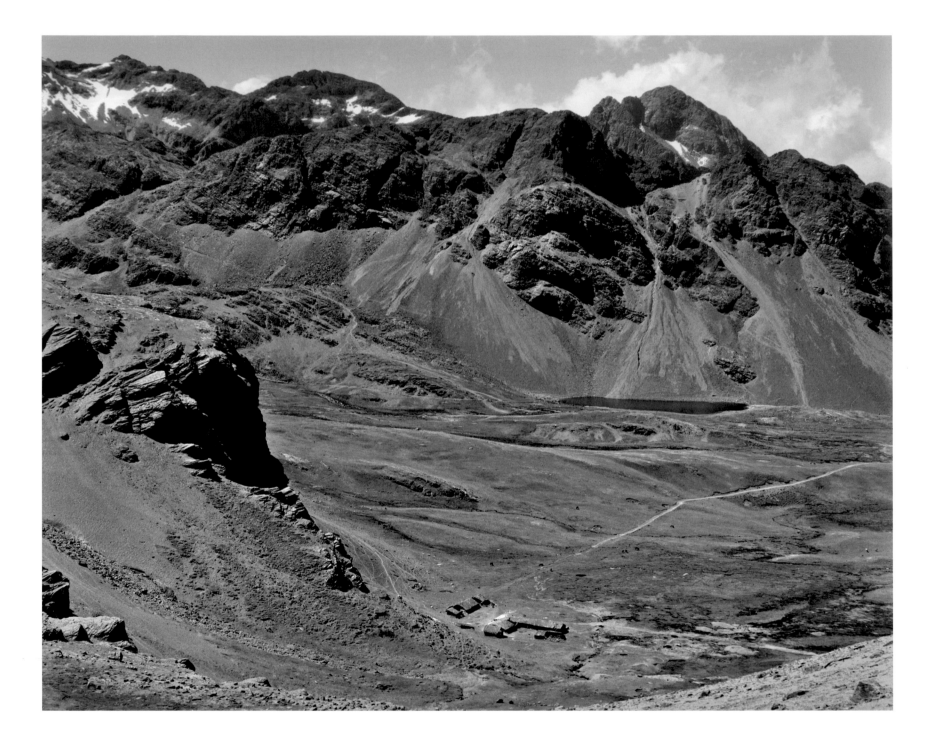

Looking east from the pass over the Cordillera de Tres Cruces between the Altiplano and Quime. The area is about halfway between La Paz and Oruro and the elevation of the road is around 17,000 feet above sea level. March 1960.

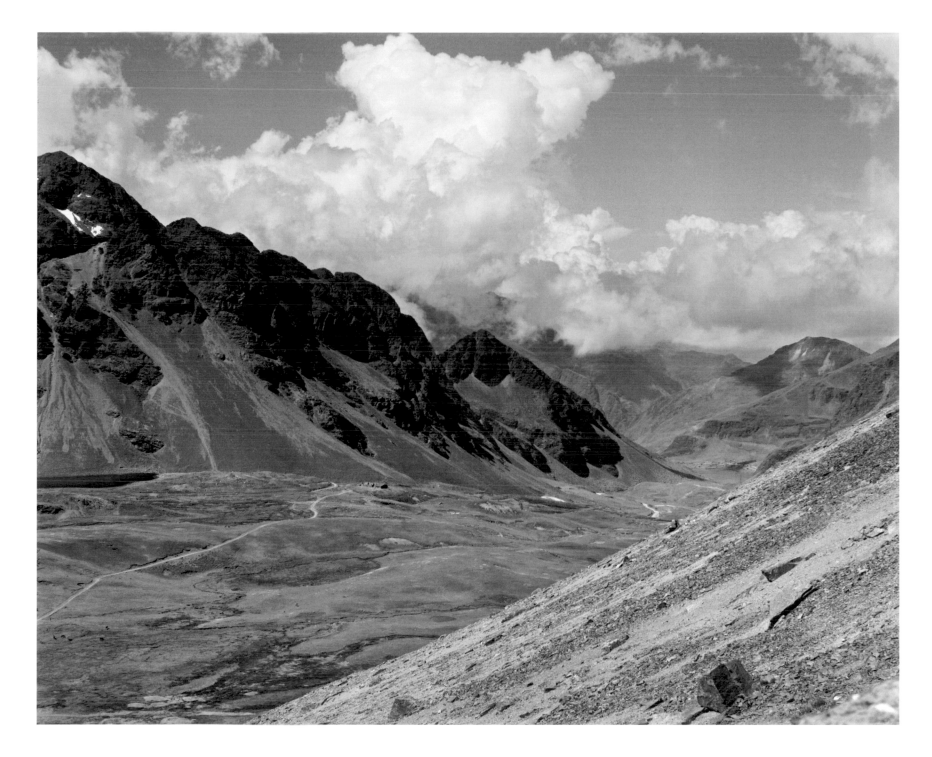

The pass over the eastern side of the Cordillera de Tres Cruces from the road to Quime. The elevation here is about 17,000 feet above sea level.
March 1960

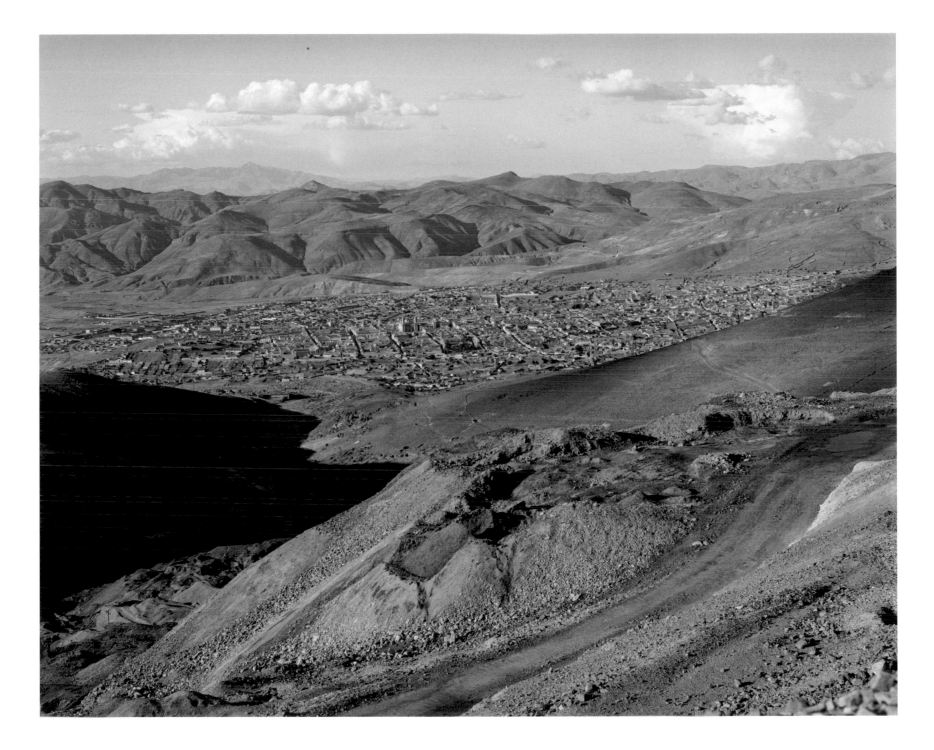

Taken from Cerro Rico, Potosí "the richest hill on Earth," from which much of the silver coinage for Europe originated several hundred years ago.
November 1961

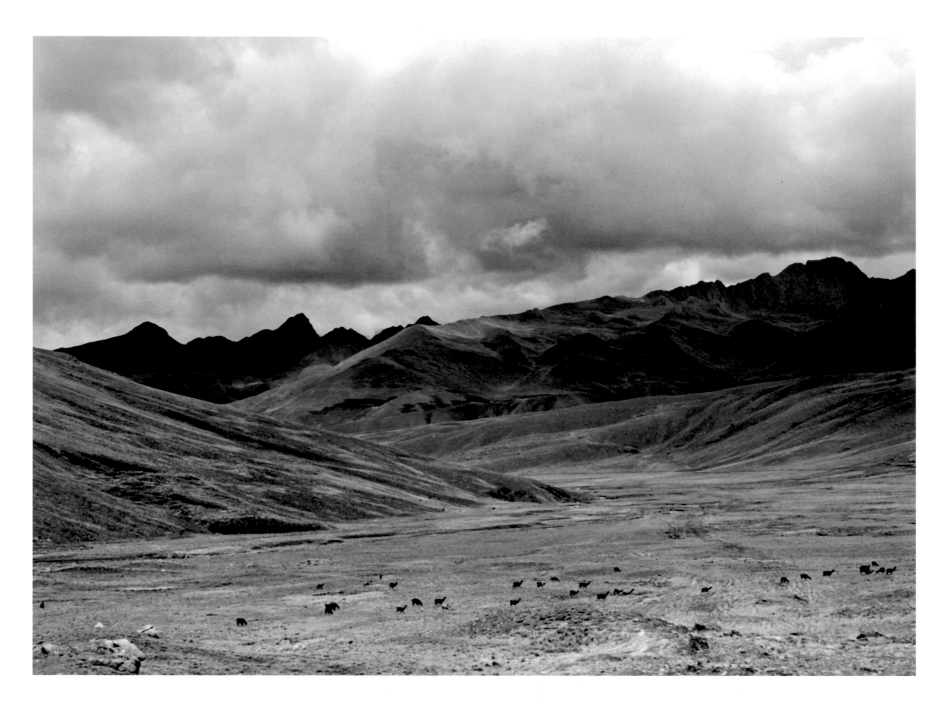

Upcountry in the Tunari range north of Cochabamba. Elevations around 16,000 feet above sea level. December 1959

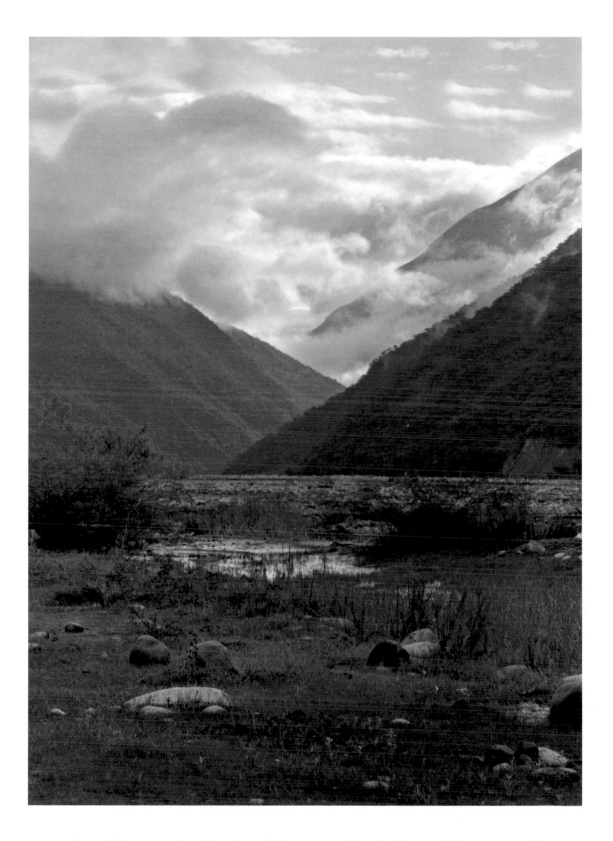

From field camp in the valley of Río de la Paz at La Plazuela. About 80 kilometers east of
La Paz and some 8,000 feet below it. March 1960

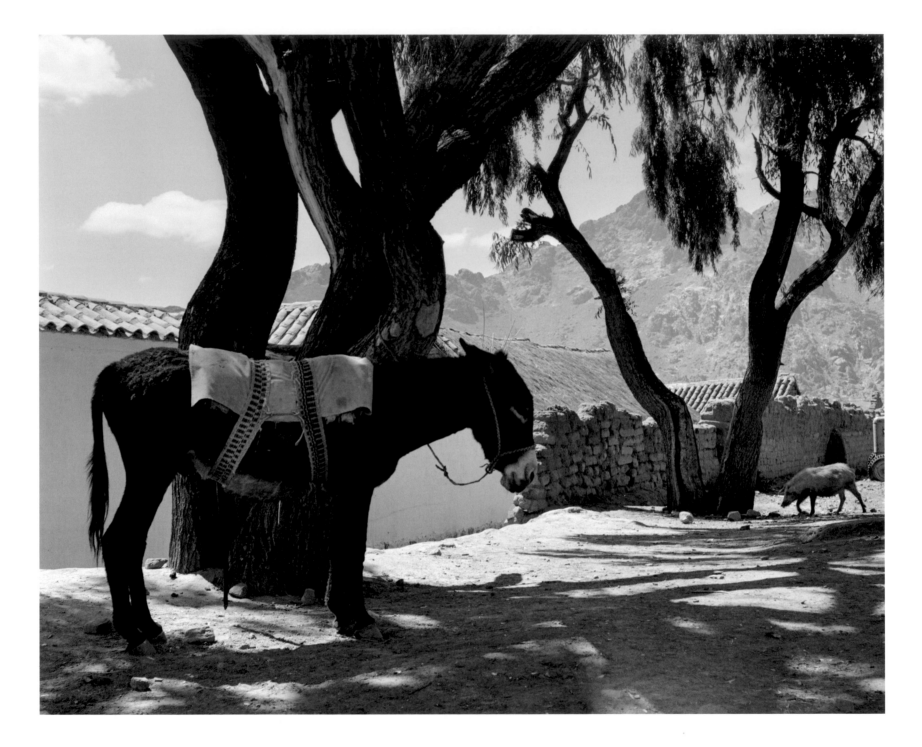

Burro taking it easy near Betanzos on the road between Potosí and Sucre. September 1961

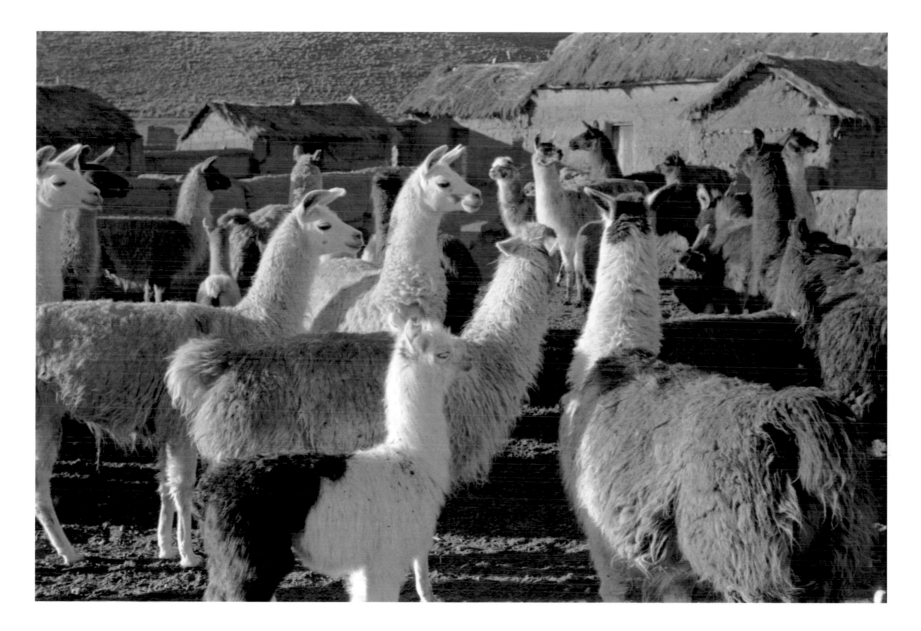

Llamas in front of my tent at Laguna Concha, on the east side of the Altiplano somewhere between Oruro and La Paz.
March 1960

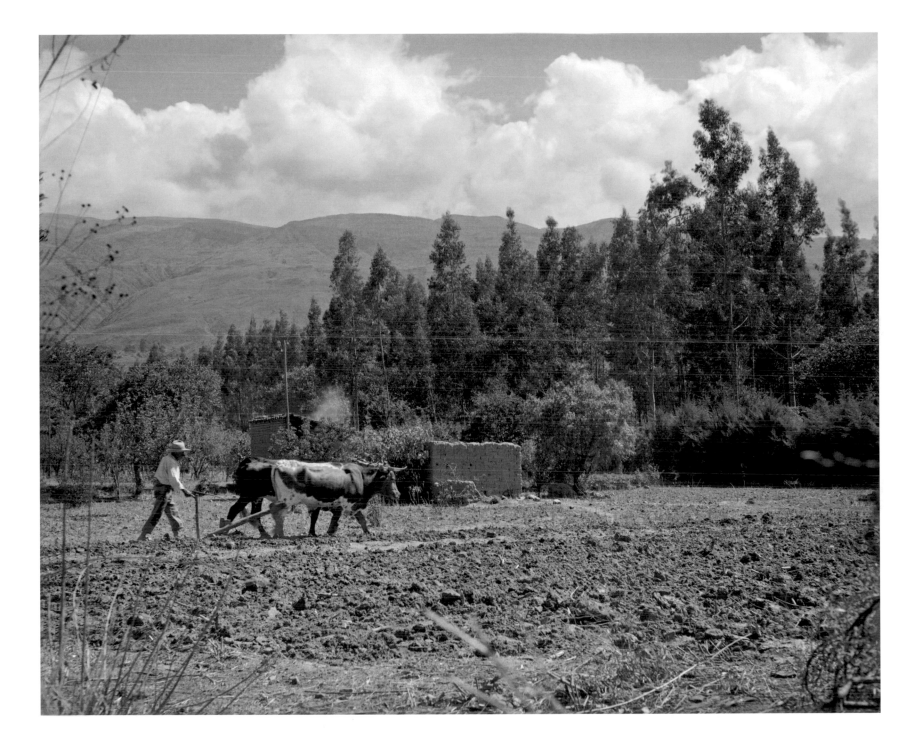

Plowing the field on the north side of our home in Aranjuez. Cochabamba.
September 1961

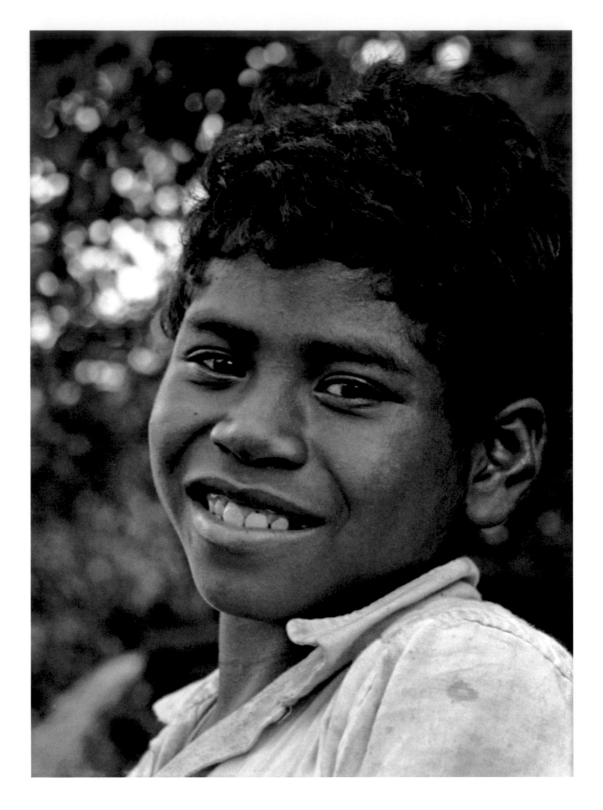

Anacleto. We spent a day or two at Colonia Siguani, far down the Río Bopi, to rest both our mules and
ourselves before returning up the river and home. Anacleto lived at Colonia Siguani and his elders
assigned him to me as my personal servant. Raul Padilla said he was a slave boy.
He just kept the coffee coming and the bugs away while I updated our maps. March 1960

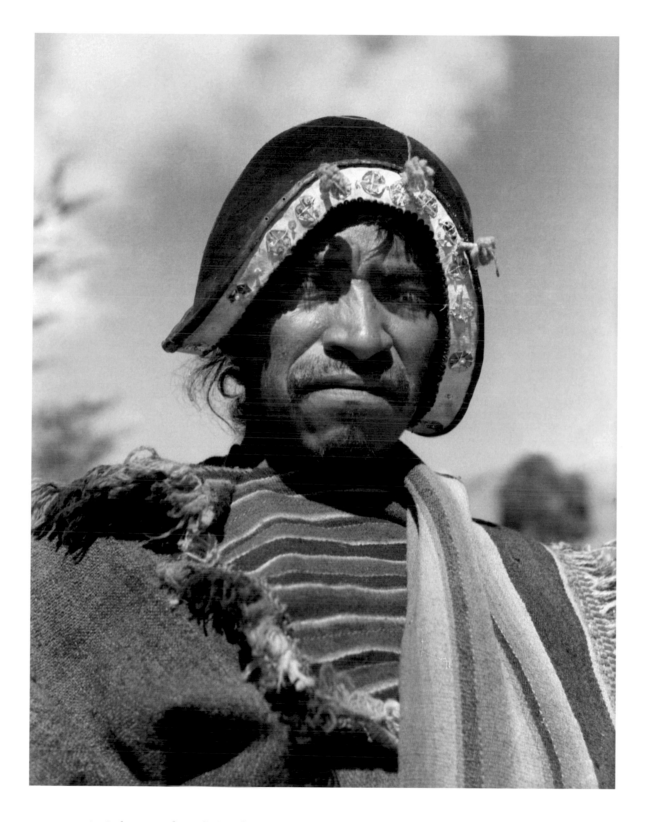

An Indian man from the Tarabuco area southeast of Sucre. The hat is typical for this area.
June 1959

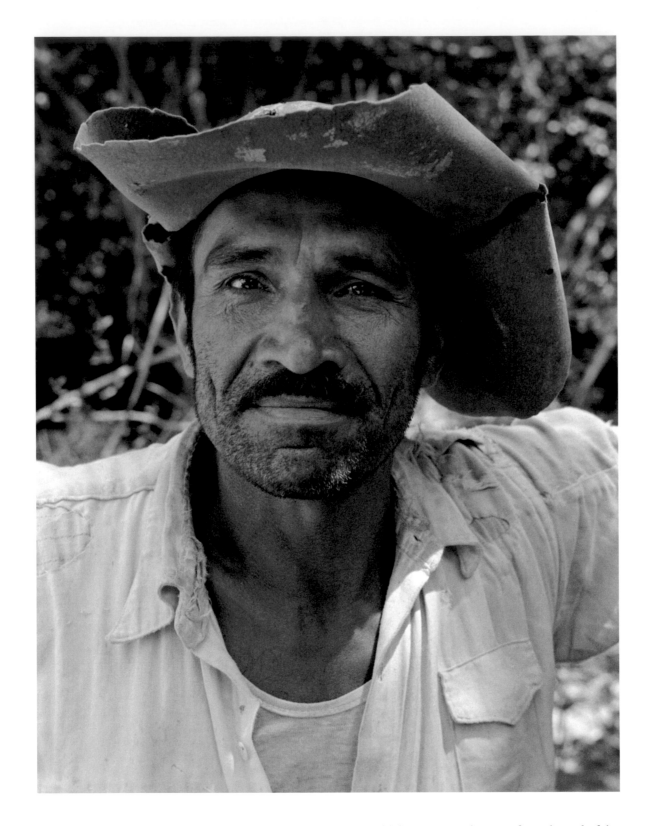

Juan Espinoza. He gave us important directions as to how we could drive our Land Rovers from the end of the Río Parapetí in the Izozog area to Estación Cañada Larga where we would find a flatcar and continue east to Roboré. Between Izozog and Cañada Larga were some 170 roadless kilometers of sparsely vegetated sand which was locally blown into large dunes. The trip took two days, about half of which was done in the dark hours while the sand was moist from the night air. October 1960

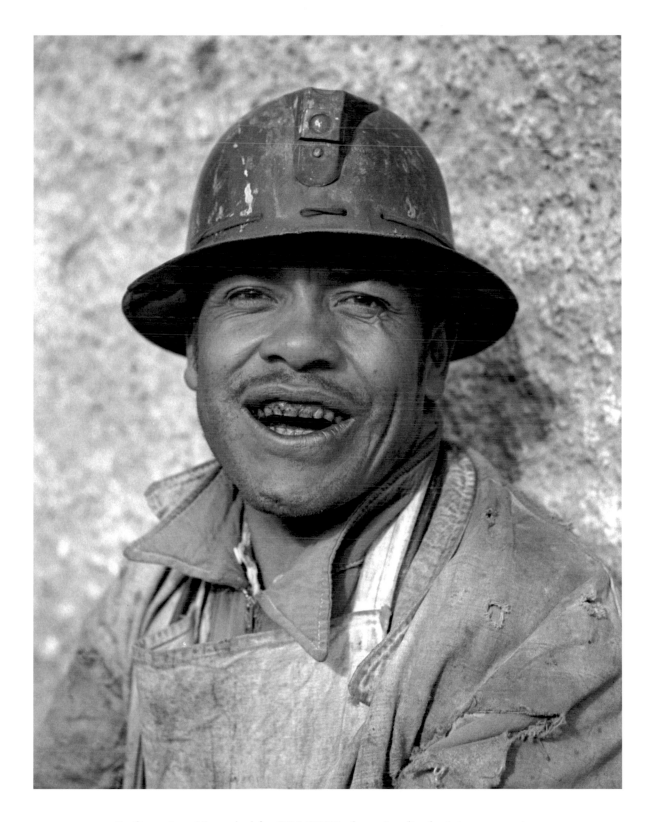

Smiling miner. He worked for COMIBOL, the nationalized mining corporation
which took over after the revolution of 1952. Potosí.
November 1961

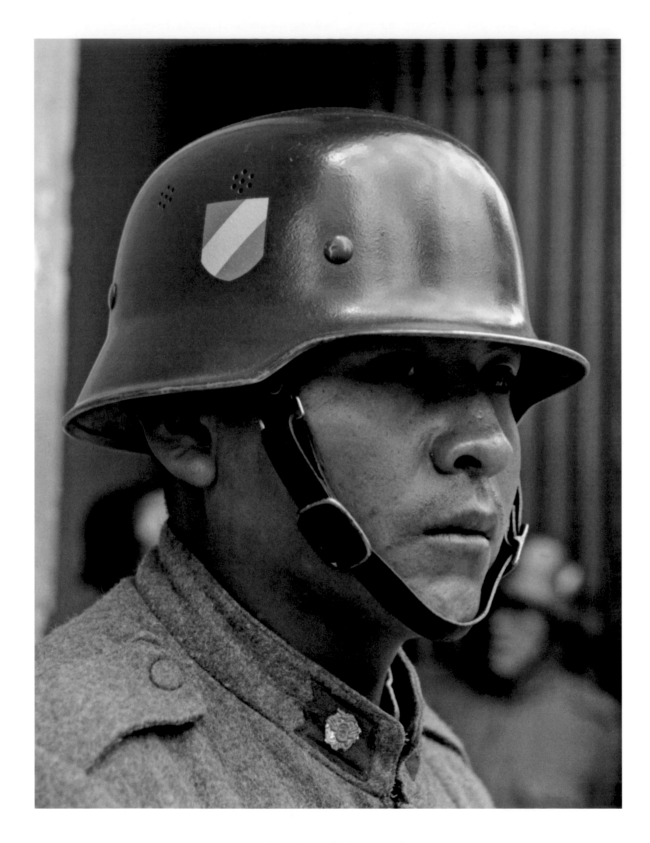

Presidential guard, Plaza Murillo.
La Paz. January 1960

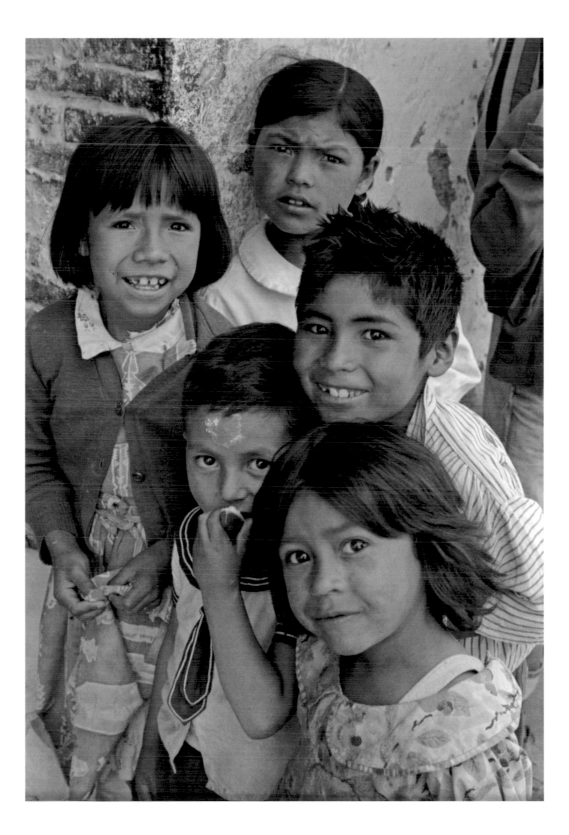

Kids.
Cochabamba. February 1961

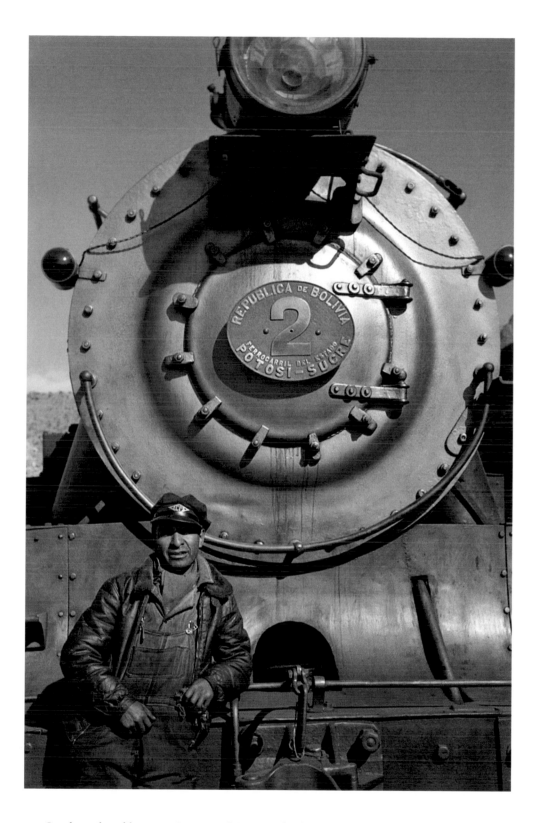

On the railroad between Potosí and Sucre. This locomotive and train kindly stopped
on a siding to let us pass in our rail car, an automobile with railroad wheels.
The engineer was very pleasant and delighted with his job. June 1959

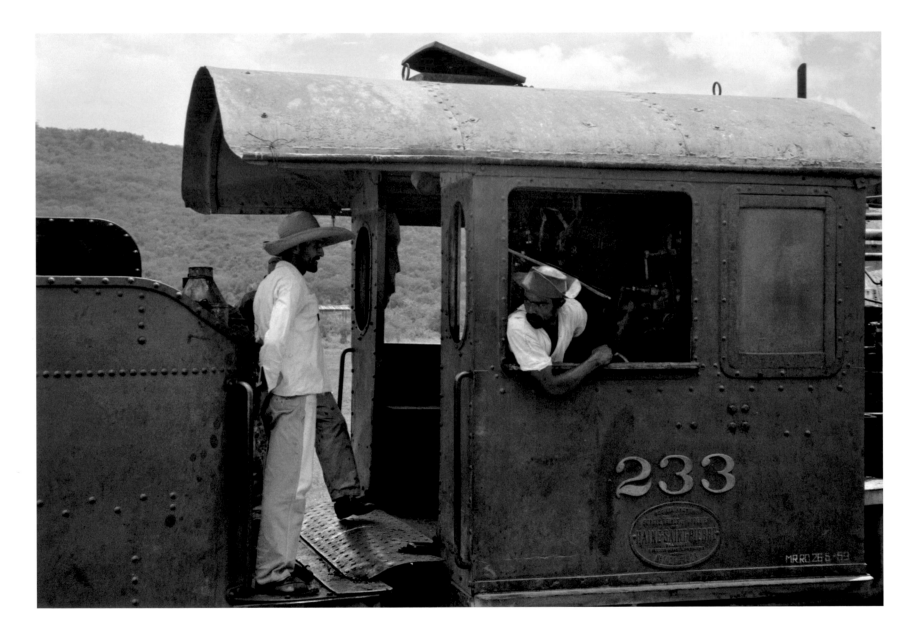

Engine 233, a wood-burner, parking water tank cars at Estación Quimome. As water was not available at most railroad stations
along the FCBB (Ferrocarriles Brasil Bolivia), it had to be tanked in, mainly from Roboré.
December 1959

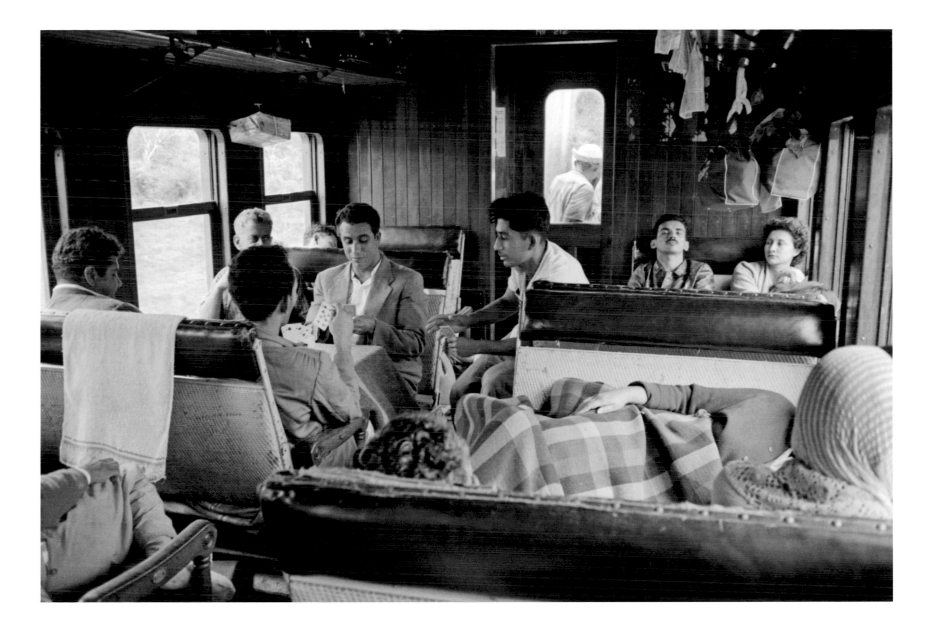

Primera clase. FCBB. Traveling west from San José de Chiquitos to Estación El Tinto.
November 1959

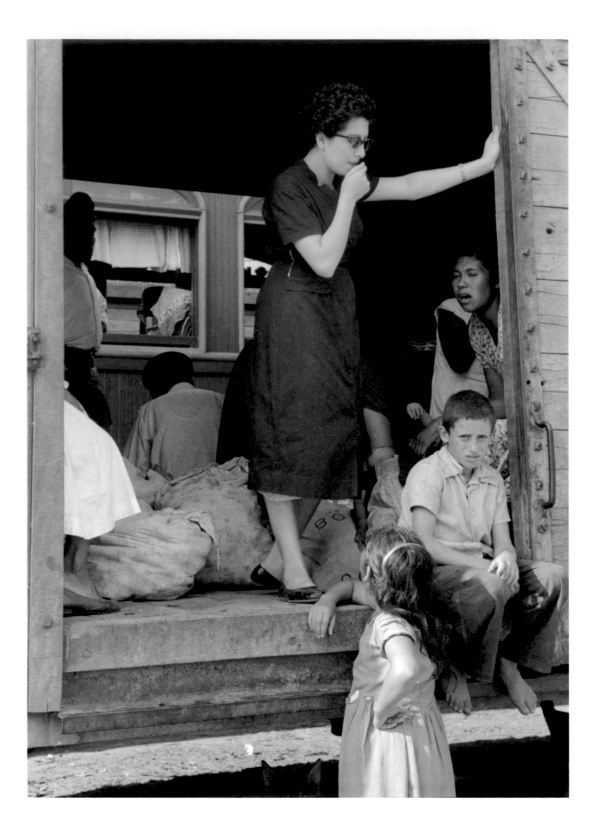

Woman standing in doorway of boxcar. A first-class car is behind her on the other track.
Boxcars and flatcars served as second class, however, flatcars were far superior to boxcars in the dry
season. The worst were empty cattlecars. San José de Chiquitos. September 1959

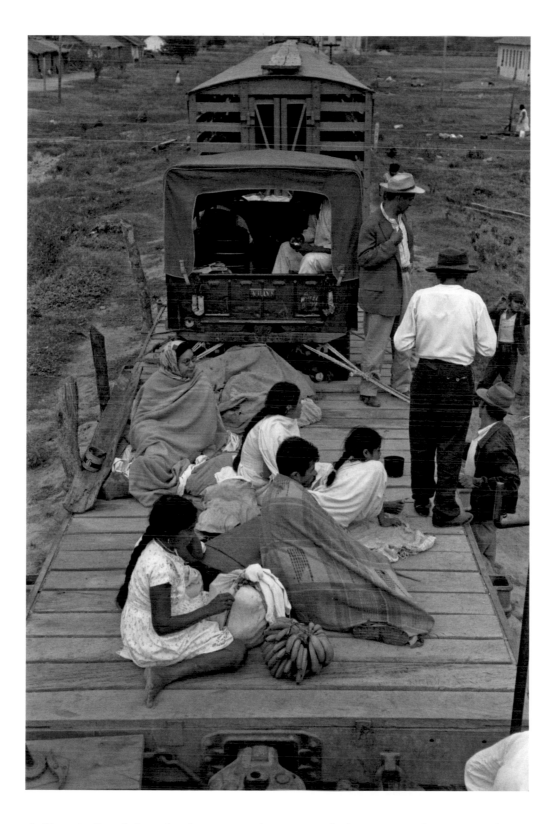

At Estación Cañada Larga heading west on the FCBB we had our two Land Rovers on a flatcar
and I took this shot from the roof of our first Rover. We were en route to the Río Grande
which we crossed by barge. Then we continued to Santa Cruz and Cochabamba.
December 1959

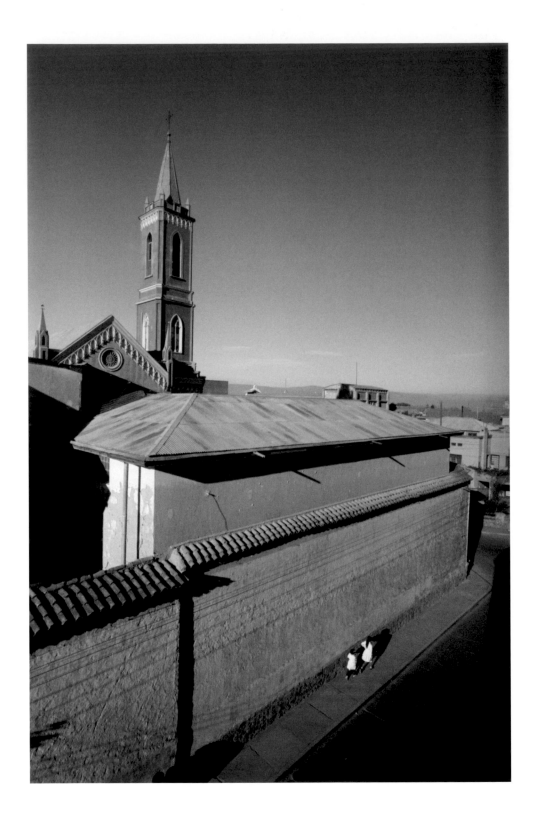

Two schoolgirls walking down Calle Colombia. Taken from the Hotel Capitol.
Cochabamba. May 1961

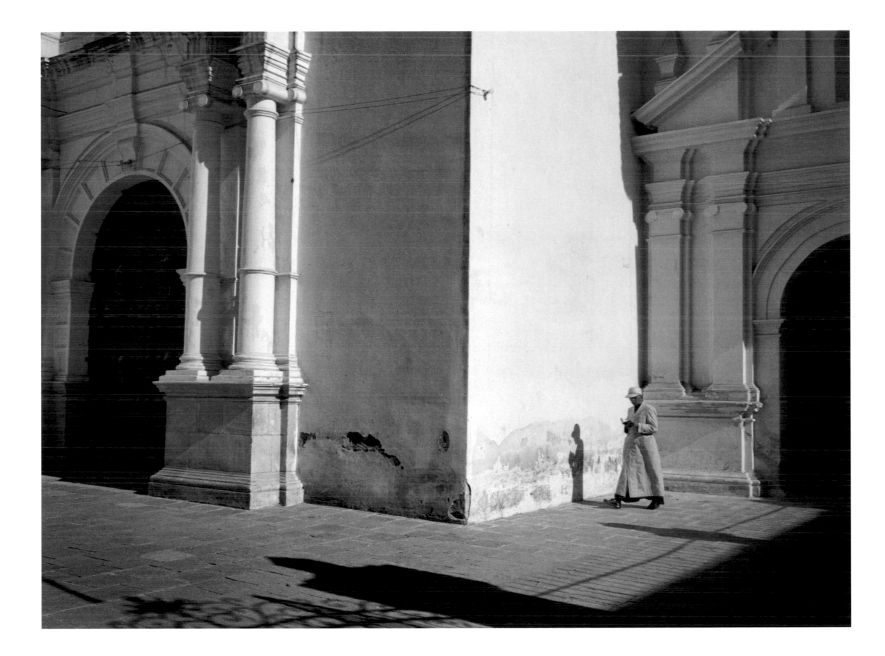

Priest at the Cathedral. Sucre. June 1959

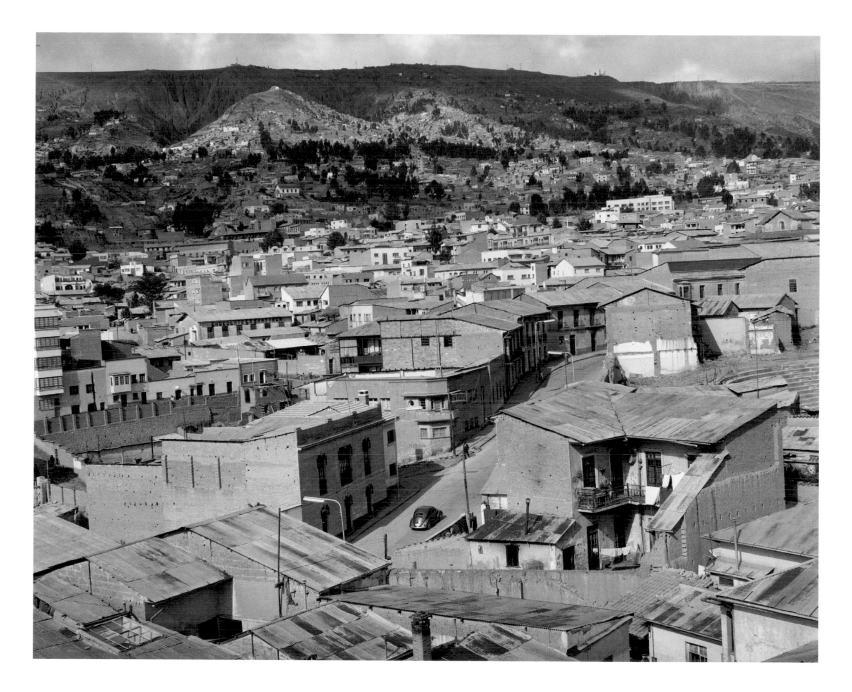

Looking southwest toward the Altiplano from the Hotel Copacabana. La Paz.
January 1960

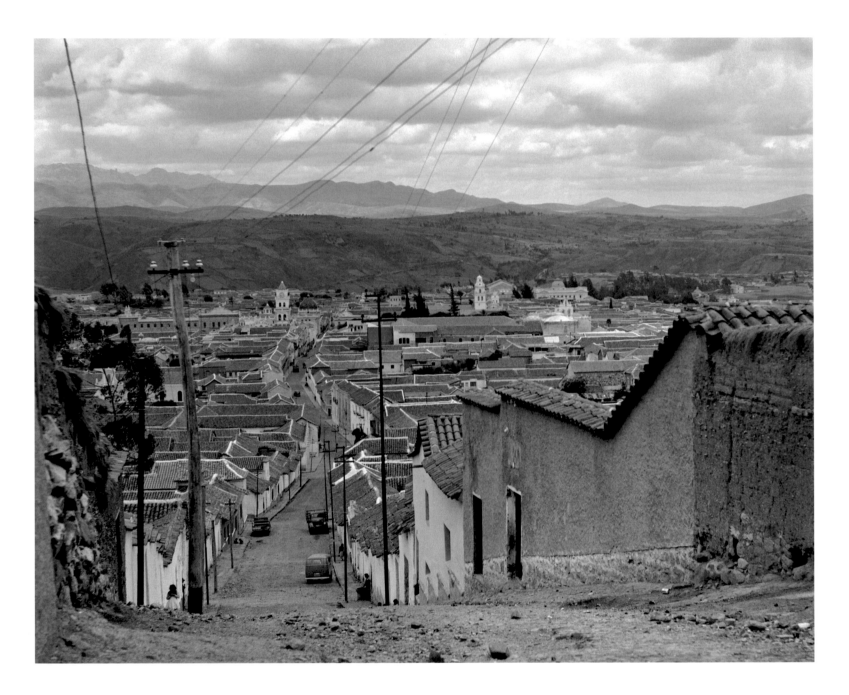

Sucre viewed from the southwest limit of the town. December 1961

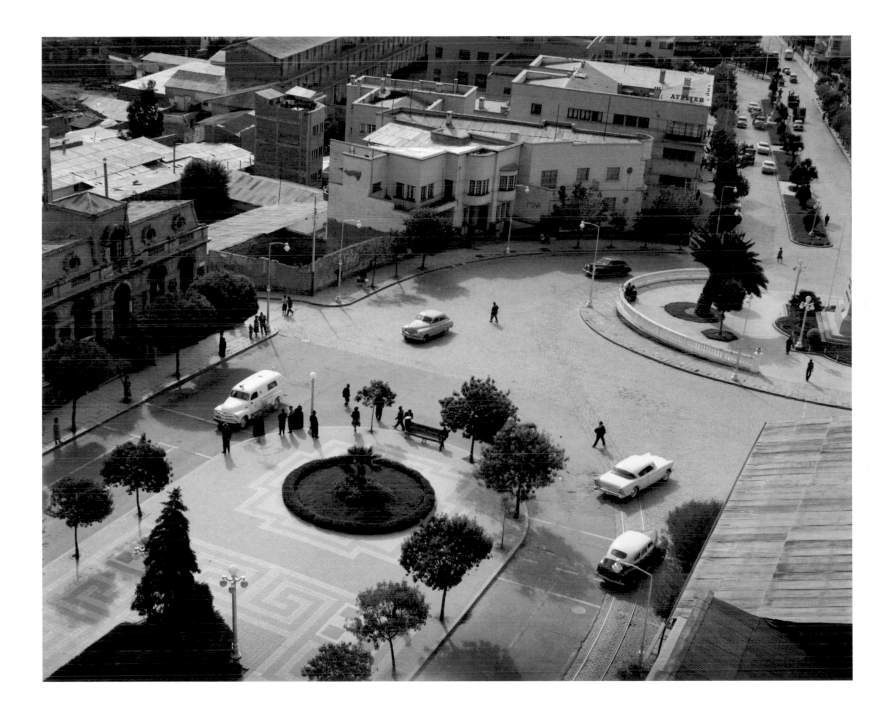

Looking southeast down the Prado toward the Plaza del Estudiante from the Hotel Copacabana. La Paz.
January 1960

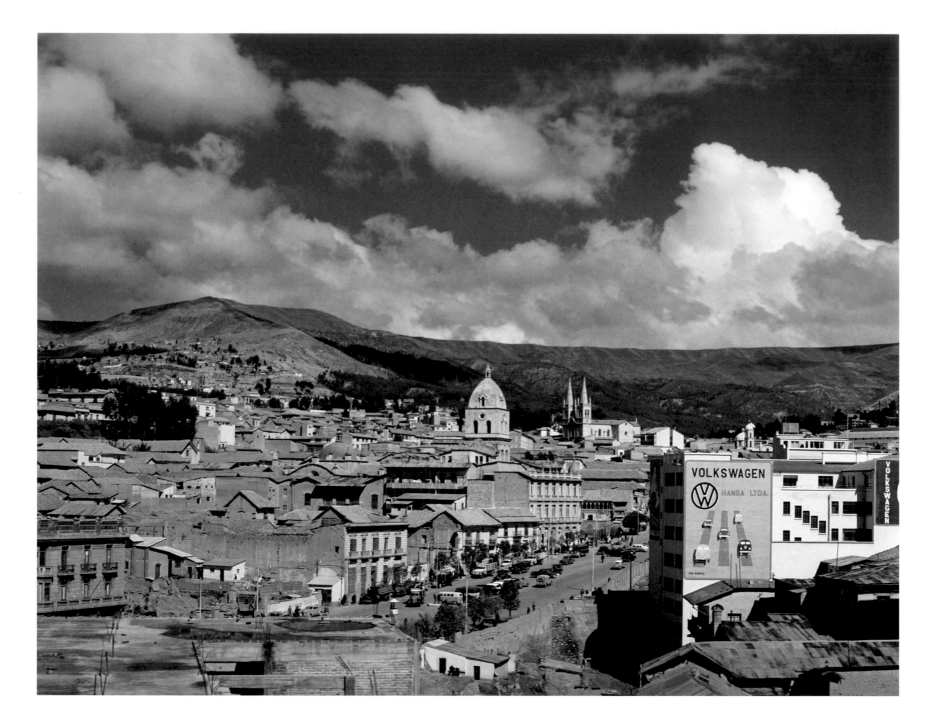

Looking southwest from the Bolivical La Paz office in the Edifico Krsul.
January 1960

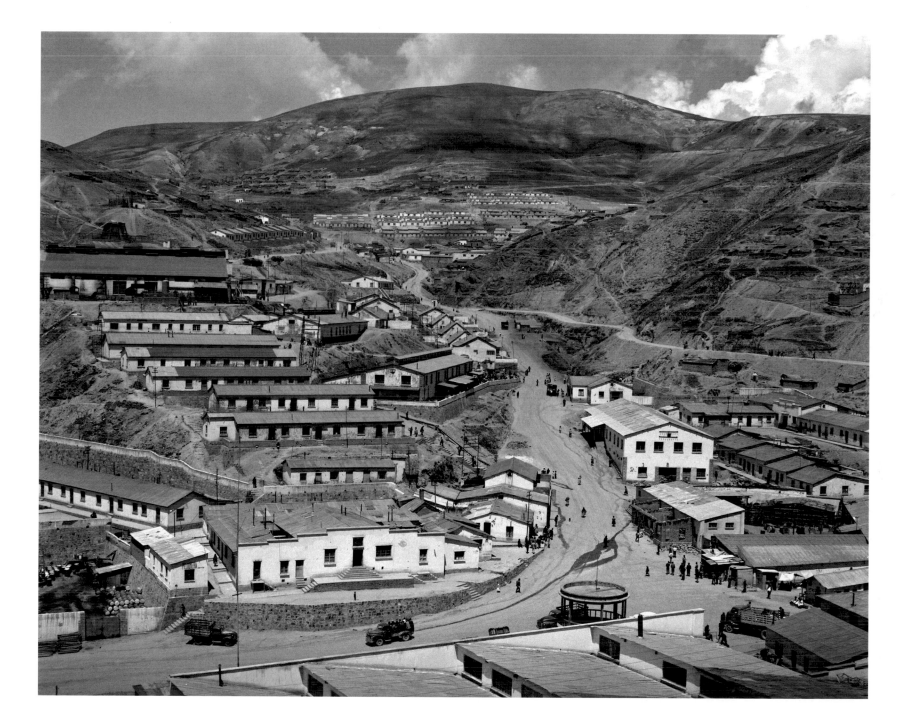

A major tin camp about 60 kilometers north of Oruro in Cordillera de Tres Cruces. Elevation here is 13,300 feet above sea level. Colquiri.
March 1960

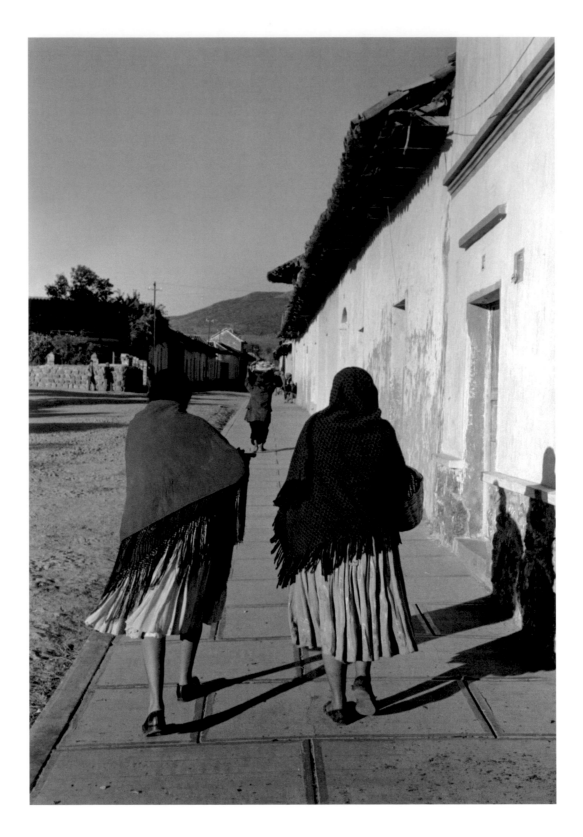

Padilla. September 1960

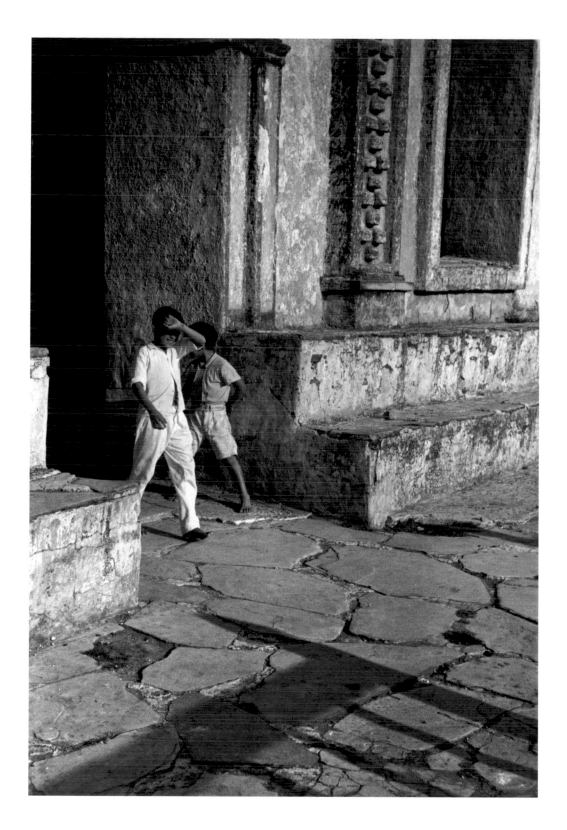

Coming out of the church. San José de Chiquitos.
September 1959

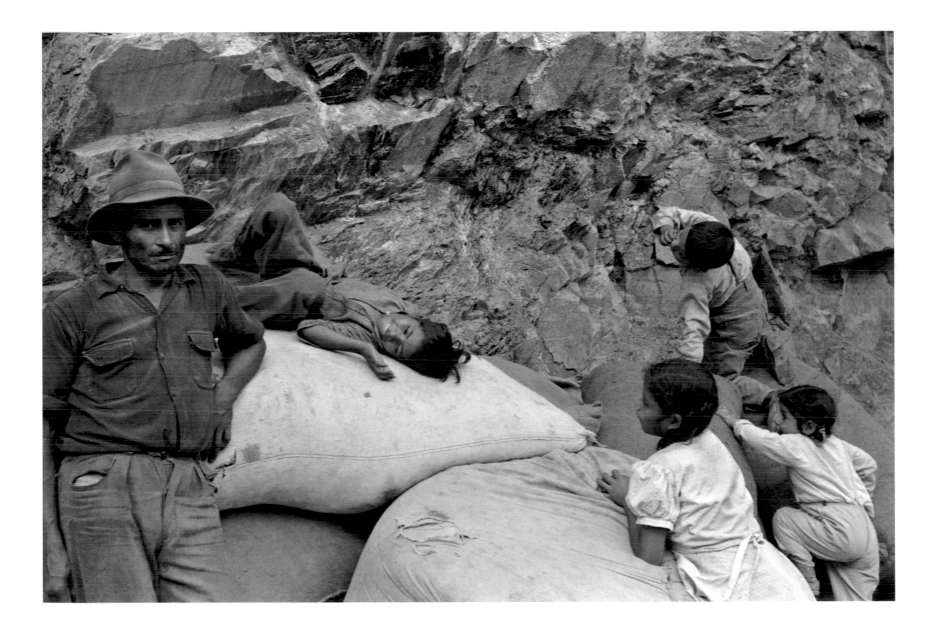

Choquechaca on market day. These large bags are probably filled with dried coca leaves, one of the main crops in the Yungas region, roughly at 3,000 to 5,000 feet above sea level. Coca was used as a palliative by the Indians against the harsh climate and the tough lives these people had to contend with in these higher, bleaker altitudes. March 1960

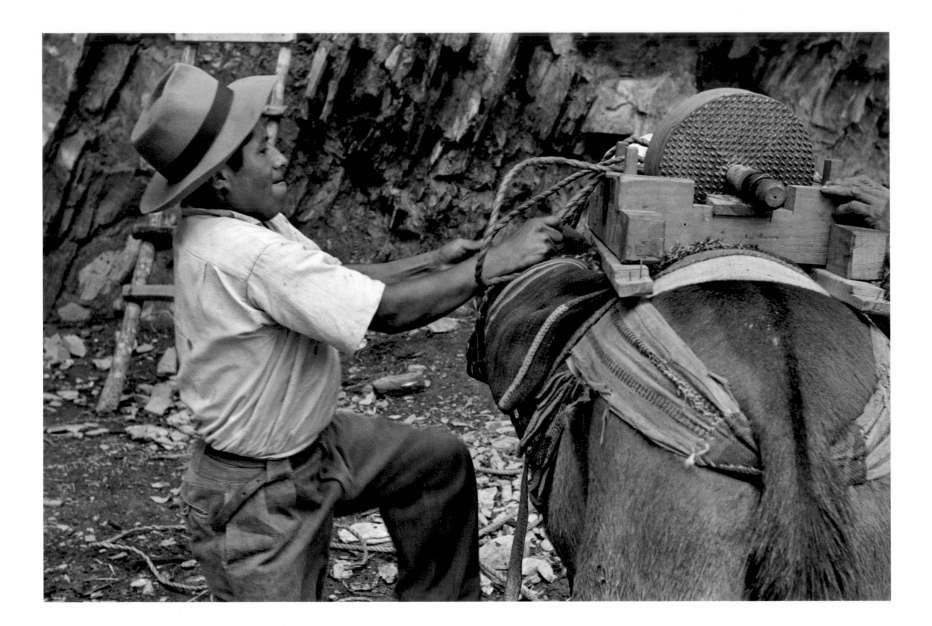

Once a week—market day—the local world descends on Choquechaca where the road from La Paz stops at the Río Tamampaya in the Yungas. Campesinos from the back country pack in their agricultural produce which include a wide variety of tropical plants, including coca, and exchange them for staples and farm equipment which are unavailable to them and are trucked in from La Paz, some 70 kilometers to the west and about 7,000 feet higher. This man, obviously, has just acquired a grindstone which his mule will pack home for him. March 1960

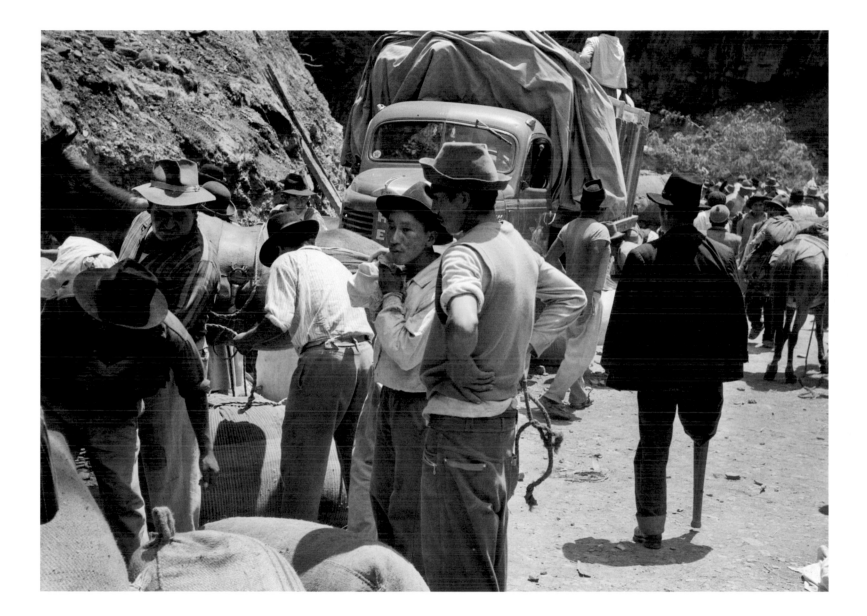

Market day. Choquechaca. March 1960

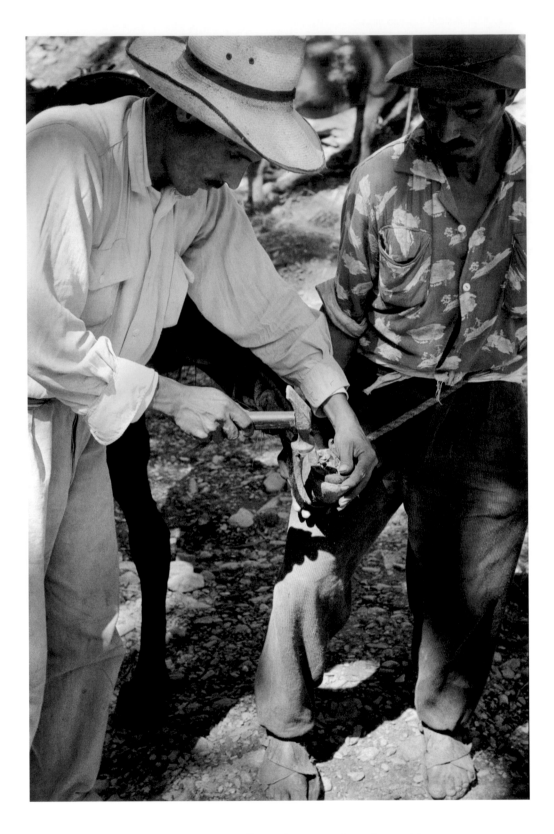

Shoeing mule near Hacienda Villar in the Yunga along the Río Tamampaya.
March 1960

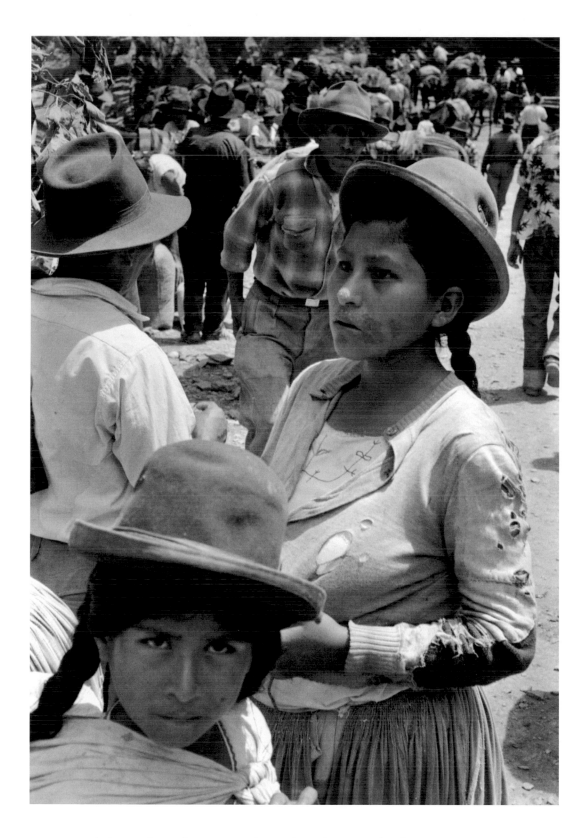

Taken in front of my tent at Choquechaca during market day. March 1960

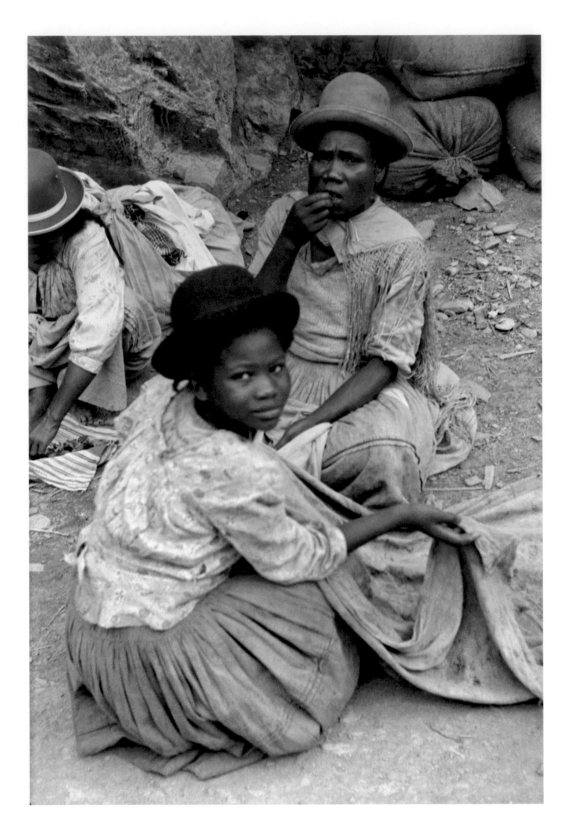

Market day. Choquechaca. March 1960

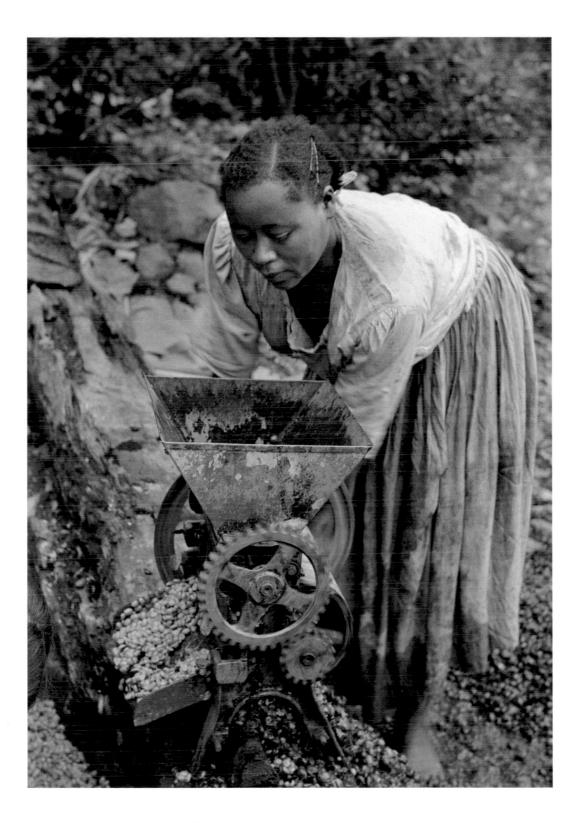

Peeling coffee or cocoa beans. Choquechaca. March 1960

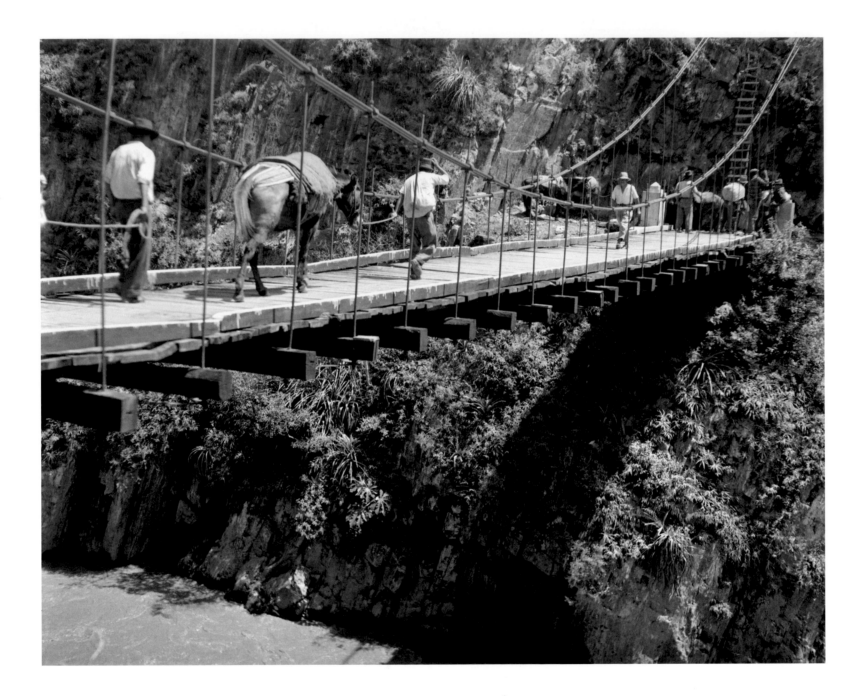

Bridge across the Río Tamampayo at Choquechaca. This bridge connects the road from La Paz with the trails in the agricultural region of the Yungas. These people are heading home with their purchases after delivering their produce to market. March 1960

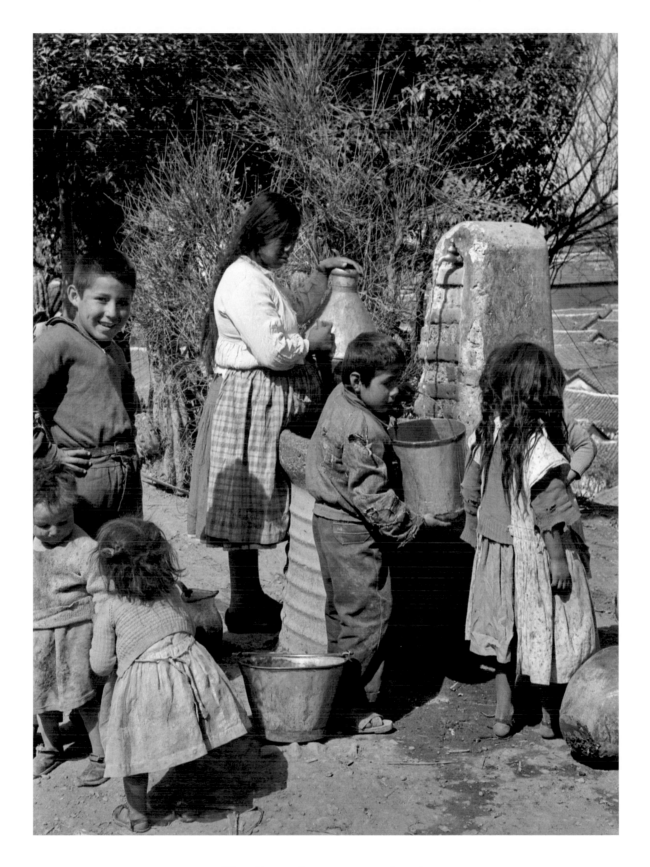

The village well. Irupana. March 1960

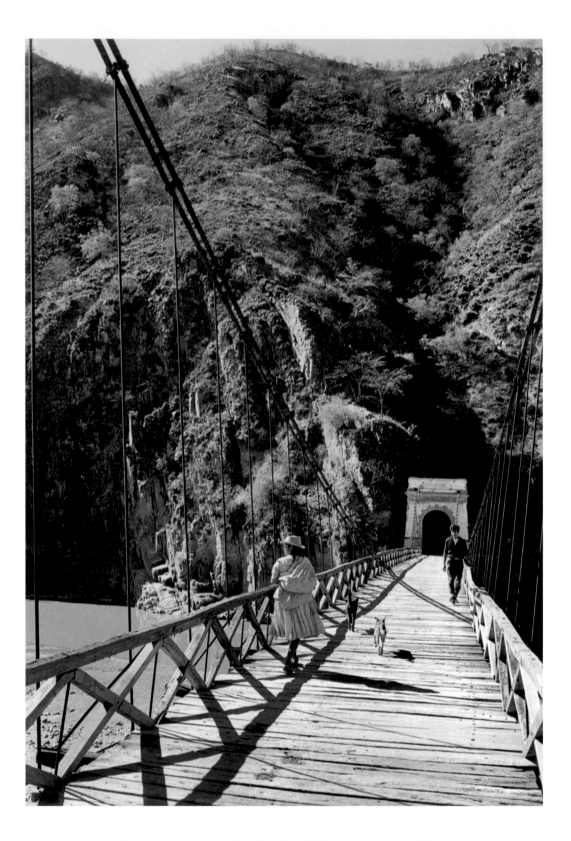

Puente Arce over the Río Grande, 45 kilometers north of Sucre.
May 1959

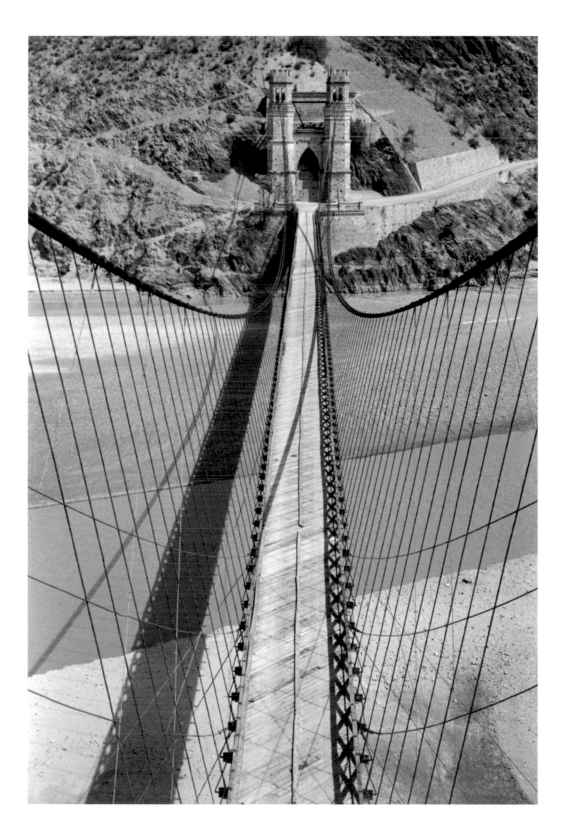

Puente Sucre, spanning the Río Pilcomayo between the cities of Sucre and Potosí.
September 1961

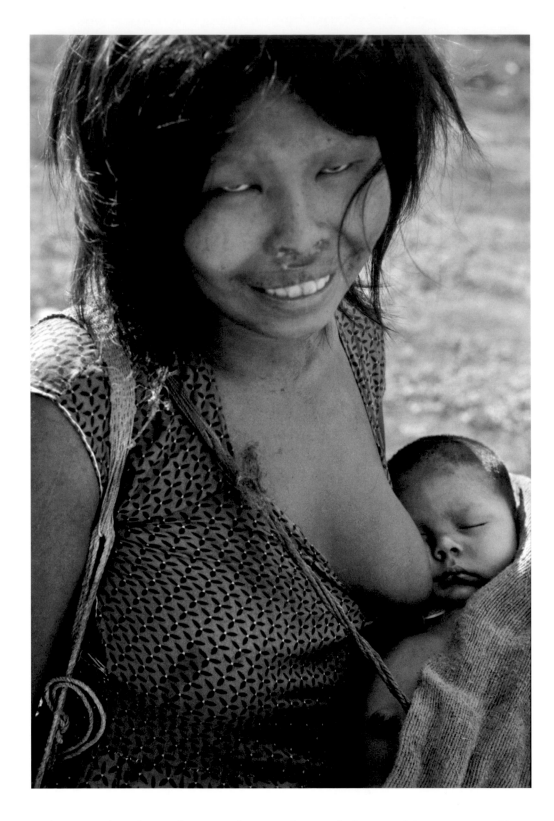

Ayoreo mother who may have an endemic eye disease which some of the missionaries, like
Doris Wagner, were trying to treat. Estación Pozo del Tigre. December 1959

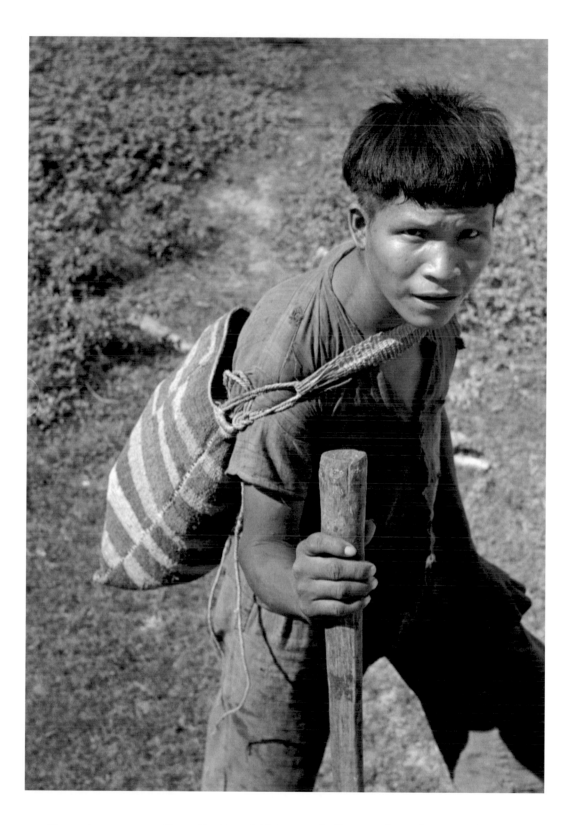

Young Ayoreo man at Eastación Pozo del Tigre on the Ferrocarril Brasil Bolivia, about 130 kilometers east of the city of Santa Cruz, Bolivia. These people number about 5,000 and live a nomadic hunting and gathering existence in eastern Bolivia and northern Paraguay.
December 1959

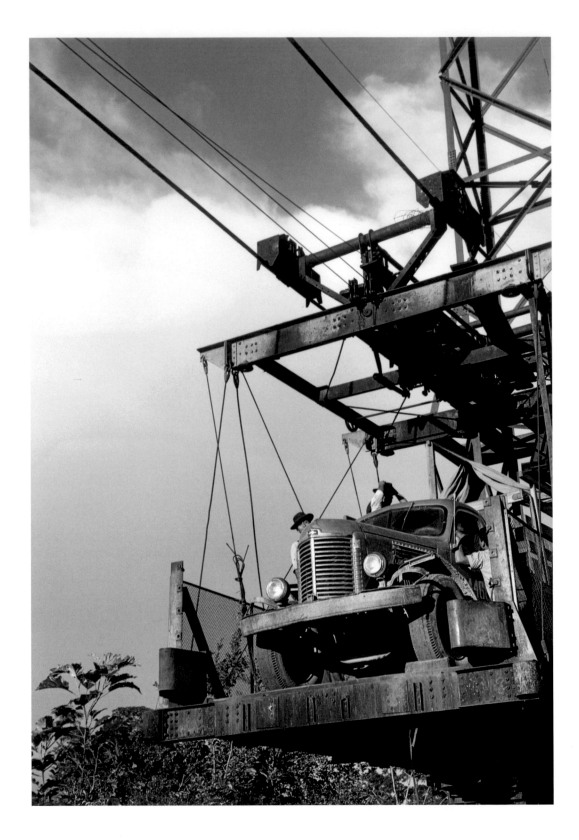

Teleférrico carrying truck across Río Espíritu Santo in the Yungas,
northeast of Cochabamba. April 1960

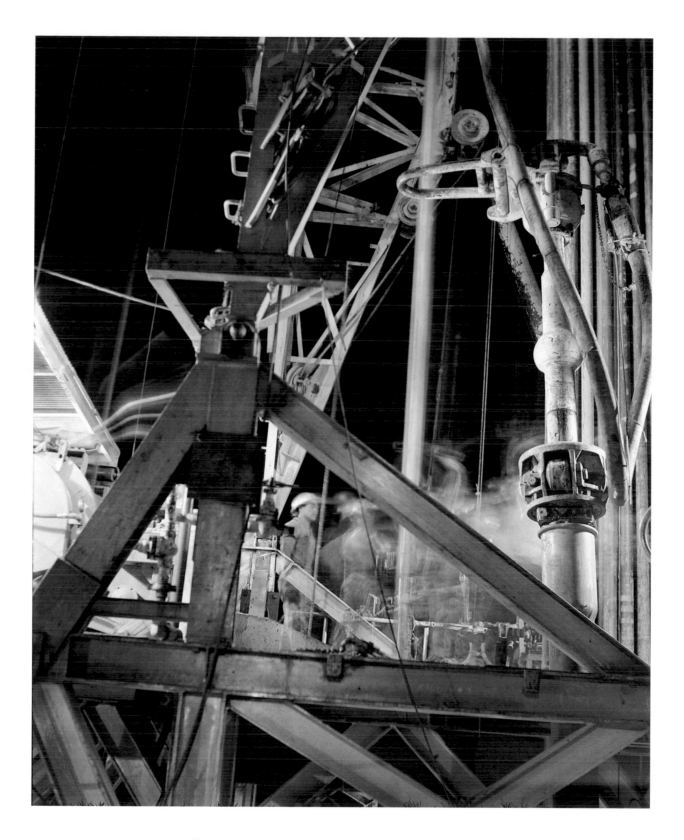

Montecristo No. 1 well. Another 15,000 foot hole in the ground that cost about $2,000,000 to drill.
This was our second dry hole and the end of our exploration in Bolivia.
September 1961

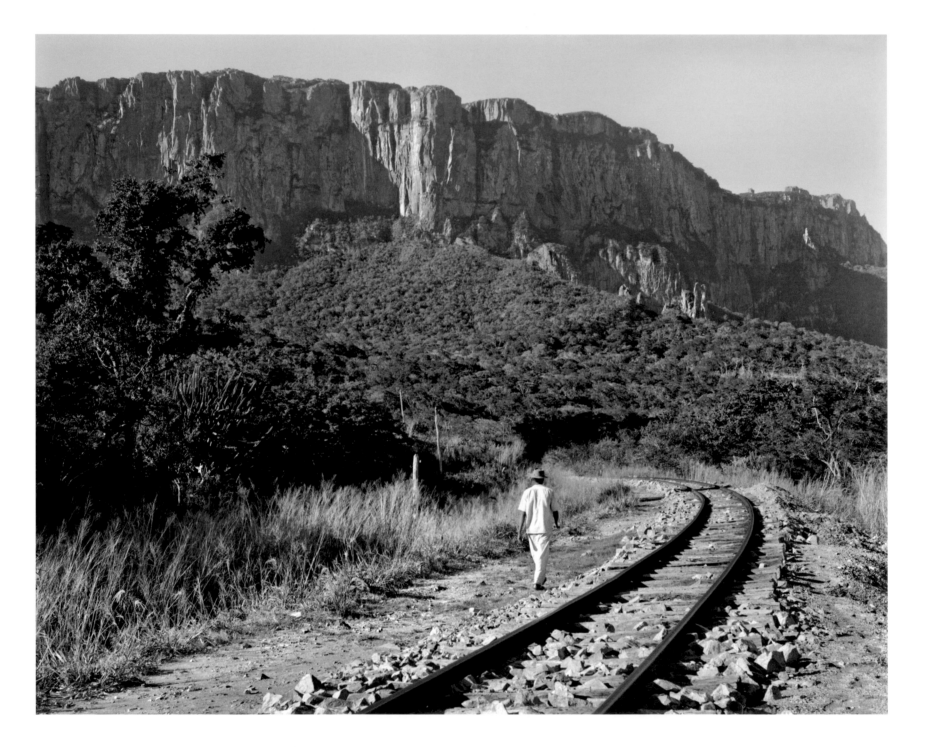

Cerro Chochís, located midway between Roboré and San José de Chuiquitos and just north of the FCBB. June 1961

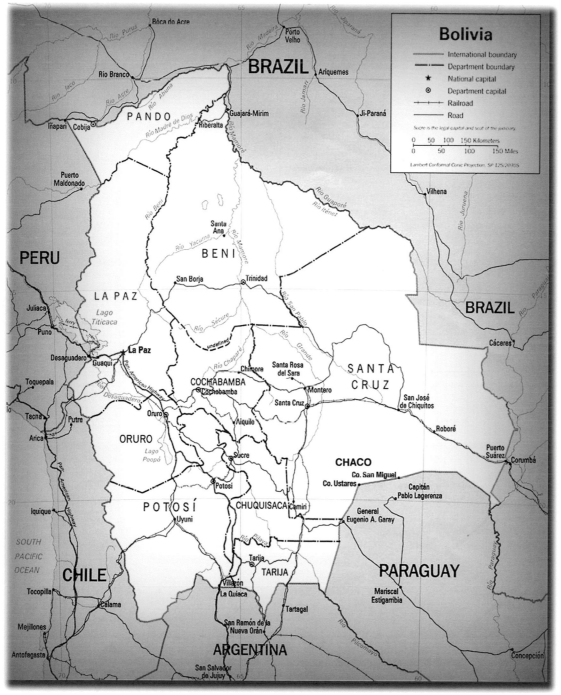

Courtesy of the University of Texas Libraries, The University of Texas at Austin